BARRON'S ART HANDBOOKS

LIGHT AND SHADE

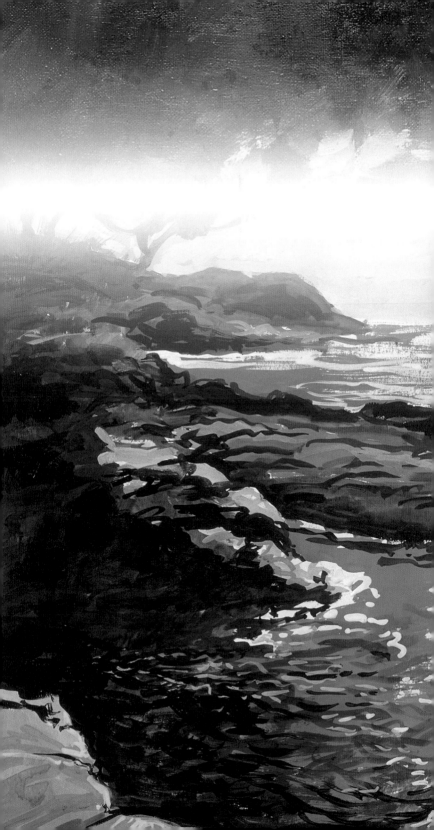

BARRON'S ART HANDBOOKS

LIGHT AND SHADE

BARRON'S

CONTENTS

PREHISTORIC REPRESENTATION

Cave paintings are the oldest evidence we have of artistic activity. From the point of view of artistic representation as we understand it today, they are works without a clear compositional organization, closely linked with the place where they were painted, and they are dependent on the characteristics of the rock that acted as a support. Many of these works are no more than silhouettes, but others show a clear intention to depict form, or in other words, show the expression of form by means of rudimentary light and shade.

Flat Colors in Paleolithic Art

Paleolithic art derived from a very elemental mentality and the representations are based on simple, flat forms, with no other intention but to depict scenes and customs.

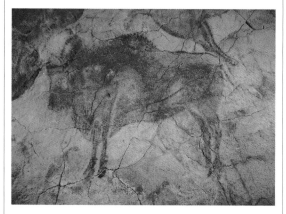

Paleolithic painting, Bison.
Altamira Cave, Santillana del Mar (Spain).

These paintings are a legacy of the life of primitive man; animals and scenes from hunting and food gathering are the main themes of these early artistic manifestations.

To create these paintings, prehistoric man used mineral and vegetable pigments that were found in the immediate environment. The earth, with its different tones—ochre, burnt and even rusty colors, a burnt log to make the color black, or the juice of the berries of a certain bush—all helped to carry out prehistoric representations. The use of these pigments mixed with fat or water and applied directly to the rock has, without doubt contributed to the flatness of the representations. As the colors were applied directly onto the rock, the effect of volume is achieved through contrast. Blending is rare, although there are some paintings in which it appears.

The Volume of Shadows. Stone

Paintings depended entirely on the stone on which they were made, although Paleolithic artists made use of their very circumstances for their creations. Since they were made on the walls of caves, some paintings are found on smooth surfaces, and are clearly painted using flat colors and linear drawings. However, some painted figures were made by using the volume of the rock, with which the artist was able to give the painting volume. The natural relief of the stone created an interplay of light and shade that helped the composition by creating the effect of a specific volume. By making use of these conditions, early artists could produce figures that suggest a certain degree of modeling. Sometimes it can be seen that the artist has smoothed the rock, to emphasize the desired form. Sometimes they smoothed the overall

Neolithic painting.

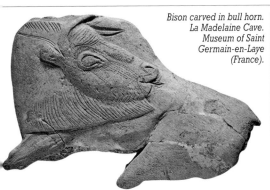

Bison carved in bull horn. La Madelaine Cave. Museum of Saint Germain-en-Laye (France).

shape of the animal to make an entire volume that was then painted. This became a polychromatic relief. It is also possible to find paintings in which the rock was first scratched, to make a type of engraving, following the outlines of the shape and the principal features: eyes, ears, horns, legs and so forth.

The First Evidence of Color

Without a doubt the first painters painted using their hands as their first tool, just as children still do today. Later they used a stick to mix the dust of the pigment. The hair of animals, the feathers of birds, or a burnt stick were the extension of the use of their hands.

Initially one can see that prehistoric artists painted in monochrome, for example by dipping their fingers in the blood of the animals that they hunted and spreading it over the surface of the wall. Later better representations can be found in terms of color, when they introduced shading by means of charcoal dust.

Polychrome was created by means of ochre and red pigments, as well as black. This polychrome was made by applying flat colors using animal fat and blood and on some occasions included shading.

New Materials

During the Neolithic period artists began to use other colors to increase their palette, especially new tones of earth colors, ochre and violets, as well as white. An important stage in the evolution toward a wider use of color during this period was the great explosion in the use of ceramics. It is also possible to find cave paintings

from the Paleolithic period with widely varying characteristics. Initially the theme becomes more complex. Entire scenes are represented, especially of hunting and cattle, although sometimes individual figures are depicted. The human figure appears, as men and women are represented performing daily tasks. Drawing becomes very important during this period, and man's mind begins to think abstractly in a more direct way, so the drawings created are very carefully planned. Human anatomy is drawn with great precision and although the use of natural supports is still utilized to create volume, volume is also conveyed by means of contrasts in colors.

The Search for Volume Using Dark Tones

The use of flat colors to create simple forms and achieve a simple representation of reality was not always dependent on the use of stone to represent volume. Prehistoric painters used a contrast in colors to establish the volumes of the figures they were representing. To achieve this contrast they basically used counterpoint, despite having a limited range of colors. Colors such as black or red were combined with more obviously light tones such as earth colors and ochre to create contrasts. This conveyed the sensation of light and shade, with the aim of creating a realistic illusion of volume.

Neolithic pottery.

REALISM IN ART.
GREECE AND ROME

During the fourth century B.C., different Greek territories achieved their first moments of splendor during what is called the Classical period. The realistic perfection that this culture achieved through art was continued and developed by Roman civilization several centuries later. Roman culture not only adopted the artistic ideals of Greece but because of its propensity for conquest, it imposed its doctrines and its art on the whole of the Mediterranean. Thanks to Roman culture we know about the aesthetics of classical Greece, as well as the techniques the Greeks used and the artistic styles that reached an advanced state of development in their depiction of volume and form.

Roman Painting as a Copy of Greek Art

Roman mural painting is based on Greek techniques and many of the works that were created are now considered copies of Greek originals. In Rome, painting was focused on decorating large buildings belonging to the nobility. The first Roman period, or painting in

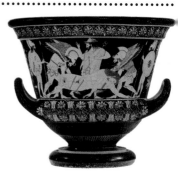

Sleep and Death taking the body of King Sarpedon, painter Eufronius, potter Euxotheos. The Metropolitan Museum of Art, New York.

tionally divides its space into architectural sections that separate the various scenes being represented, which are usually mythological in subject. As far as the technique of painting is concerned, most noteworthy is their mastery of the fresco painting, which continued to be the main pictorial medium for many centuries. Fresco pain-

ting is characterized by its use of the moisture in plaster as a medium for diluting pigment, so that as the wall dries, the paint hardens and becomes permanent. This is one of the techniques that ensures the best conservation of pigment, and so it is not surprising that the Roman pigments survived the passage of time. For the

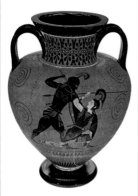

Achilles' spearing of Penthesilea, Queen of the Amazons, by Exekias, painter and potter. The British Museum, London.

the First style as it is known, is considered the most strongly influenced by the earlier Hellenic model. Later Roman art moved away from this style, although artists continued to make use of the Greeks' knowledge of color and perspective. Roman mural painting tradi-

Charon instructing the young Achilles (fragment). A possible copy of an original by Apelles, mural painting found in Herculaneum. The National Archaeological Museum, Naples.

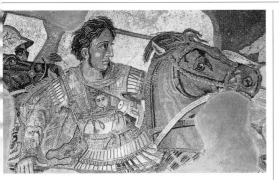

Mosaic of Alexander the Great fighting the Battle of Issos (fragment). Copy of a painting by Apelles and his disciple Filoxenes, found in the House of Faunus, Pompeii. National Archaeological Museum, Naples.

and shading, with the result that one can see a combination of ornamental and realistic aspects. Bright color dominates in these works, but at the same time one can see how volumes are constructed using an interplay of tones of light and shade, which gives a more realistic depiction of the figures.

This mastery of light and shade and the sensation of volume is also reflected very clearly in Roman pictorial representations of architectural forms such as vaults, arches, and columns.

Many murals exist painted on architecture that depict views through windows, and the results are surprising, not just because of the mastery of color but also because there exists a perfect knowledge of perspective, which adds a strong sense of reality.

same reason the fresco was hugely popular in other periods, particularly the Renaissance.

Mural Art

When discussing mural art, we must consider Roman painting, since very little Greek painting has survived. There are four categories of Roman painting: inlaid, architectural, ornamental, and illusory. Each of these categories was developed at very specific times, although they also overlapped, as is common in the history of art.

The Roman architect Vitrubio in the first century A.D. described the preparation of the support as follows: "Six layers of calcium are applied successively onto a well-dampened wall. For the first, the calcium is mixed with coarse sand; for the second and third it is mixed with fine sand. The three final layers are mixed with marble dust and are smoothed while they are still wet, until the final layer shines like a mirror."

What mostly characterized mural painting was the search for a realism that suited decorative necessities. For this reason one can see in mural painting how drawing is executed with maximum rigor, according to the canon of the period. The color used in every scene was rich and varied, as the full spectrum of colors was basically known during this period. In murals one can see how the concern with the depiction of reality led artists to practice a mixture of colorism

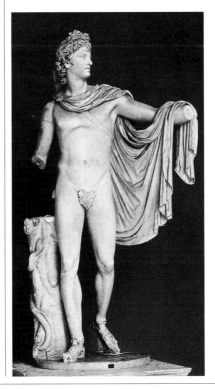

Roman copy of a Greek sculpture. Apollo of Belvedere. Fourth century B. C. The Pio Clementino Museum, Rome.

ART DURING
THE MIDDLE AGES

During the Middle Ages art lost the sense of realism it had achieved in the Classical period and became a vehicle for the explanation of Christian religious ideas. During this period painting was mainly restricted to the religious art of the Church. Style was based on flat colors that depicted divine images. It is not until the Late Gothic era, with the rediscovery of classic art and the advent of oil paint, that the depiction of volume and realism reemerge. Oil paint was ideally suited to the modeling of form, particularly in the figure, the interest in which was revived with the shifting mind set about to flower in the Renaissance.

Romanesque Painting

The roots of Romanesque art are found in the social and cultural evolution around the year 1000. The figurative arts of the Romanesque period—sculpture, painting, glasswork, and mosaic, cannot be understood separately from its architecture, and still less from the Church. The main pictorial vehicles of the Romanesque period were mural painting (combining fresco and tempera painting), mosaic, glasswork, painting on board, and handicrafts. The type of drawing characteristic of this time is based on the simplification of forms to the basic geometry of the circle and the square. Figures are characterized by symmetry and flatness, and images are expressed with a linear quality.

Flat Colors

The system of representation used during this period goes back to Egyptian painting. They are explanatory, didactic paintings in which the effect of realism is less important than the contents or the meaning of the image. Simple drawings are used, with outline and flat coloring. Although the figures appear unreal, the symbols that represent them are clear and would have been easily understood by the viewer of the time, who was unconcerned with artistic considerations.

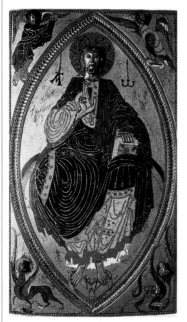

Romanesque painting. Christ the Judge surrounded by four forms. Evangelist cover. Musée de Cluny, Paris.

Scenes and Details

It has sometimes been said that the true museum of Romanesque art can be found in illuminated books. The demands of the liturgy were embodied in a taste for slow, meticulous work, appropriate to monastic life. Evangelists, the Bible, and monastic charters provide a more authentic introduction to the concepts of Romanesque art than do monumental painting. Some unfinished manuscripts allow us to follow the process of illustration of a manuscript, as they feature many preliminary sketches, the intermediate stages with basic colors, and finally the finished faces, clothes, and other motifs.

Miniature. Feudal vassal. Liber Feudorum Major, end of the twelfth century. Archive of the Crown of Aragon, Barcelona.

Realism in Art. Greece and Rome
Art During the Middle Ages
The Realism of the Renaissance
11

The colors used were mainly variations of red and black, and because of trade with the East, the introduction of blues and golds. The increasing complexity of color sophistication slowly perfected the images in Gothic painting.

Gothic Painting

Gothic art flourished in Western Europe from the thirteenth century, developing as an evolution of Romanesque art. The Gothic aesthetic is defined as the art of the city, and is closely linked to the birth of social structures such as guilds, which allowed the subsequent evolution towards the Renaissance. During the period of Gothic art, techniques and pictorial typologies were basically the same as in Romanesque art, although they were more or less developed, depending on the area. While miniatures and the illustration of manuscripts was flourishing in France and Germany, mural painting reached its splendid peak in Italy. The altar-piece was unquestionably the form that expressed the greatest beauty in the field of painting, highlighting the Christian philosophical inclination toward establishing divisions and creating order systematically.

Early Gothic forms display a desire for harmony, with a leaning towards curvilinear volumes both in facial features and composition in general. Towards the end of the thirteenth century, the linear rhythm ceased to be a fundamental element, and Cennino Cennini, in his book *Libro dell'Arte (Treatise on Painting)* underlines the importance of color over line.

Gothic painting. Virgin and Child (detail). Musée de Cluny, Paris. The virgin in majestic pose and the flat forms are characteristic of medieval religious painting.

Return to an Understanding of Light and Shade

In the field of painting, artists such as Duccio di Buoninsegna or Giotto were the first whose paintings showed this new conception of painting, based on a mastery of color, and consequently of atmosphere and volume. Giotto was the great renovator of art in the transition from the thirteenth to the fourteenth centuries. Before him, figures had been treated as colored silhouettes, isolated bodies against a flat background. Giotto placed these bodies in an architectural space or landscape that had previously been reduced to the level of background scenery. In his works, light and shade are combined with an accuracy that creates depth and the suggestion of the infinite. Thanks to him, painting abandoned idealism and returned to realism. The Italian artist no longer painted archetypes but rather from observation, and now figures interacted with and appeared to inhabit a world that was their own.

Giotto, Saint Stephen, altarpiece. Horné Museum, Florence.

THE REALISM OF THE RENAISSANCE

In the fifteenth century there was an artistic and cultural revolution in all areas of art and philosophy. The Black Death had devastated Europe and reduced its population by half. Conditions changed so radically that thought began to separate itself from Christianity and to find new forms of expression and understanding. These sources of thought found inspiration in the Classical roots of ancient Greece and Rome, considering that period to have produced an ideal standard as well as the highest expression of beauty in art.

Modeling Volumes of Light and Shade

The art of the Renaissance was a realistic art. Its maxim was to achieve the closest possible likeness of the model by means of illusion, and so for this reason during this period, the modeling both of figures and of the other elements of composition was executed as exactly as possible. The great step of the Renaissance was to give a flat surface the appearance of three dimensions.

To achieve this goal, a way of working was developed that has lasted into the present, that of drawing, painting, and sculpting from life. Drawing as a tool for the process of creating art would be the key element discovered by the artists of the Renaissance. The

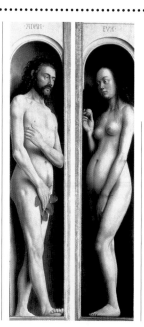

Jan van Eyck, realistic figures of Adam and Eve, polyptic of the Adoration of the Lamb, oil on board. Cathedral of Saint Bavon, Ghent.

observation of light falling on a three-dimensional model offered a series of variations in shadow, by means of which the volume could be depicted in two dimensions.

Light and Shade by Means of Color

As has already been mentioned, one of the great discoveries of the Renaissance was perspective. Perspective is almost always imagined as a linear method for representing

Florentine and Venetian Schools

The Florentine school was characterized by a type of Mannerist painting, based on drawing, line, the mastery of anatomy by means of foreshortening, and the meticulous representation of parts of the body. The most important representative of this school was Michelangelo, and before him Botticelli. Leonardo and Raphael also passed through Florence, leaving their mark. In Venice a very different type of art developed, which led to a more atmospheric and pictorial form of painting, inspired by the *sfumato* of Leonardo. The Venetian artists were responsible for the artistic change that led to the Baroque period. In the Venetian school, the importance of line gave way to the atmosphere of color. Forms were separated by a change in tone, and line disappeared. From this school emerged the great painters in the art of blending, the master of whom was Titian.

Botticelli, Abundance. British Museum, London.

space, but it is also a system that allows the artist to represent tonal gradation in the different planes of a scenic painting. Chromatic intensities are reduced as the planes move further from the viewer. This is another way of creating perspective.

While this occurs with color, it also occurs with areas of light and shade in relation to the source of light and to the objects placed between them. Shade increases the further it is from the light source, whereas light and bright points intensify as they grow closer to it. Apart from this fact, it is also worth mentioning that shade is situated according to perspective, in the same way as are the tiles on the floors that are so representative of this period.

Foreshortening and the Study of Light

Foreshortening is a method by which the proportions of an object undergo a reduction

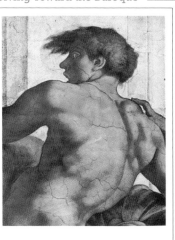

Michelangelo, detail of paintings of the Sistine Chapel. Figure.

because of the optical effect of perspective. You could say that foreshortening is the particular pose that conveys the greatest sensation of three-dimensionality, as there is always a part of the volume that comes directly toward the viewer. The view causes forms to appear compressed or distorted, and they are represented as such. This foreshortening is almost always presented with lateral light, which is ideal for representing volume by means of the shade it casts. Michelangelo's Sistine Chapel offers a great gallery of foreshortenings.

Sfumato

Sfumato is an Italian term that refers to a type of vaporous modeling, a dim outline which, according to Diderot, was "a way of bathing outlines in a light vapor." However, *sfumato* should not be confused with chiaroscuro. *Sfumato* should be thought of as an optical effect of the light that affects both the outline as well as the color of objects, depending on their distance from the viewer. It creates an atmospheric vision of reality, without either separations or outlines between objects, but rather they are seen as elements in juxtaposition that are defined by changes in the light.

This term above all applies to Leonardo da Vinci, who achieved great and beautiful illusions of atmosphere. His characters were not outlined, but modeled by areas of color and light through the abundant use of shadowing and glazing.

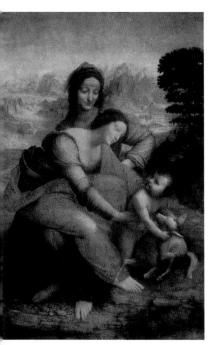

Leonardo da Vinci, Virgin and Child with Saint Anne, *oil on board. Louvre Museum, Paris.*

EVOLVING TOWARD THE BAROQUE

With Titian and the other painters who were trained in Venice, there emerged a change in painting, which was the beginning of Baroque art. Mannerist line was gradually forgotten, and painting became much more atmospheric, opening the way to the artistic goal of expressing reality. Line disappeared except in the field of drawing, and painting tried to portray reality by means of color and changes in light. Leonardo's *sfumato* helped to inspire a radical change in painting, with light becoming the source of the image and the work of art.

Realism Through Light

During the Renaissance, the visual arts were oriented toward the straightforward copying or imitation of nature.

In the Baroque period, artists aimed to express reality by means of the effect of light as it was cast onto objects. This involved a careful study of light that, without doubt, was the direct legacy of the discoveries of the Renaissance and the study of nature. Painting achieved a sensuality that had never before been seen, as light introduced strong contrasts, making the volumes of the figure, for instance, seem to leap out at the viewer. Contrasts of light and dark became the central point of works of art, giving rise to tenebrist painting, the dark palette of the Baroque.

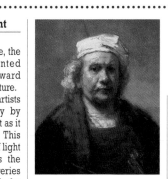

Rembrandt, Self-portrait. Kenwood House, London. Notice the treatment of the skin by means of the chiaroscuro particular to the Baroque.

The Drama of the Composition

Tenebrist painting, and Baroque painting in general, are defined by the darkness of the artist's palette. These works are endowed with powerful contrasts. Dark colors and black are the main elements of the scenes depicted. In Tene-

brism, color is not as important as image. Nevertheless works are painted atmospherically, and in the absence of drawn lines, the painting is based on the blending of tones between highly luminous areas and deep shadows. This monochromatic, contrasted aspect of painting is what characterizes the work of the seventeenth century. Throughout Europe painting achieved an extraordinary splendor.

The use of these resources of light was a great step toward the dramatization of subject matter. The dramatization of light by means of using a lateral or

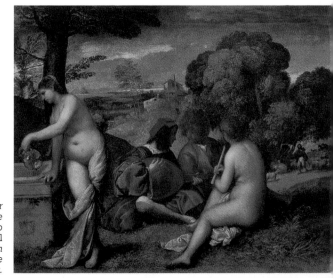

Titian or Giorgione (authorship disputed), Pastoral Concert, oil on board. Louvre Museum, Paris.

verhead light source, depending on the theme, became even more accentuated if the light was diffuse. Indeed, in most Baroque painting one can notice a diffuse light that enters the scene by means of a window located to the side of the painting.

The Triumph of Chiaroscuro

Chiaroscuro is a technique that consists of modeling by means of light on a dark background. In this way, contrasts are achieved that suggest volume and depth. The precursors of chiaroscuro are Leonardo da Vinci and Giorgione. But it was during the Baroque period that chiaroscuro achieved greater relevance, becoming the style of the era. The stunning contrasts of tenebrism were brought to mastery by Caravaggio, who made chiaroscuro his own, accentuating the dramatic nature of the scenes he painted. Chiaroscuro was also used by Titian, Velázquez, and Rembrandt.

Light and Shade in Composition

Baroque composition broke with everything that was characteristic of the art of the times. During the Renaissance one can see that elements of composition are autonomous, and that their observation does not depend on a vision of the whole. Baroque style, on the other hand, ensured that no detail of the composition had meaning on its own, but instead served the vision of the entire work, treating it as an indivisible whole.

As well as being characterized by a greater freedom, Baroque composition is also based on diagonals, curves, and spirals of motion, with the result that there is no sensation of static in the works

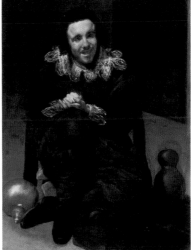

*Velázquez,
The Jester
Juan Calabazas
(John Pumpkins),
oil on canvas.
Prado Museum,
Madrid.*

of this period. Accompanying these new methods of composition were effects of the light.

Baroque compositions are noted for the illusion of light falling upon objects and figures within a particular setting. In this way, their situation within this passage of light defined their importance within the composition. The objects that were most highly illuminated took on the most importance, while the secondary objects were obscured in shade, almost hiding them from the viewer, as if the artist did not want them to be immediately seen.

The Baroque Relationship Between Background and Figure

Although Mannerism had lost all sense of realistic space,

depicting isolated objects against abstract backgrounds, without atmosphere or depth, the Baroque recovered its naturalistic depiction, giving it importance and focus.

During the Baroque the most commonly used way of creating the sensation of spatial depth was by means of foregrounds that were exaggeratedly large. Figures appear so close to the viewer that the viewer feels totally immersed in the scene.

Baroque backgrounds are also an achievement that contributed to what is known as atmosphere, so that the figures are immersed in a type of half-lit scene, with the result that outlines are always a little undefined, conveying the sense of mystery in many works.

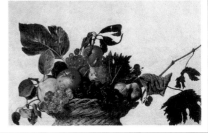

*Caravaggio,
Basket of Fruit.
Pinacoteca
Ambrosiana,
Milan.*

ACADEMIC STUDY

The academic movement began in France during the reign of Louis XIV. European art academies were the patrons of artists and established an aesthetic prototype determining accepted forms of painting. Subject matter was also restricted to scenes from history, mythology, and portraits. The academic style continued the investigation of form and volume with the same perfection as the Baroque. But it used more light and color and avoided drastic and dramatic contrasts, seeking a more sophisticated style.

Tonal Values and Modeling in Neoclassicism

Ingres, Portrait of Monsieur Bertin *(detail), oil on canvas. Louvre Museum, Paris.*

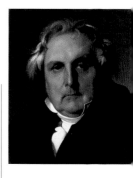

The first great Neoclassical painter was Jacques-Louis David, whose work is characterized by a great mastery of line and composition. His work shifted away from atmospheric painting, to the extent that line and drawing become important again. Figures were painted in marvelous detail, rich in description and finished with great virtuosity. Ingres, David's student, followed him in the Neoclassic style, though Ingres' work is more Renaissance influenced. The suggestion of Mannerism is also clear in his radical nudes, created with large, round forms, portraying figures that are huge and massive, illuminated against a dark background, so that the characters seem close to the viewer. Light tones are wonderfully blended to create flesh tones, and the result is stunningly realistic. Nevertheless, Ingres' figures are somewhat distorted in their tendency towards elongation.

Jacques-Louis David, The Sabine Women, *oil on canvas. Louvre Museum, Paris.*

Light, Shade, and Blending Tones

During the eighteenth century, a debate between color and tonal value took place. The way in which light phenomena were depicted was the main source of the disagreement within the world of painting, and to take one side or the other radically altered the nature and look of painting.

With regard to the study of light and shade during this period, one can observe how each artist had his own character, while remaining safely within the bounds of the dictates of the academy.

Neoclassicism reclaims the technique used by the Flemish painter, Peter Paul Rubens, combining washes with impasto. Color is not the main objective, but rather the quality of drawing and the use gradations of tone and chiaroscuro to achieve volume. For this reason, blending was used in order to achieve realistic representations of texture and form.

The Study of Anatomy

The study of anatomy allows the artist to better understand

Pastel Techniques

Pastels consist of powdered mineral pigments that are mixed with chalk and various binders to make a drawing stick. The capacity of pastels for blending is considerable. Its pigments can be spread more densely and solidly than crayon or charcoals. This capacity for covering a surface became key to painting in the eighteenth century. Many portraits were painted using this new, revolutionary technique, creating delicate, luminescent details of great subtlety and softness that fitted perfectly with Rococo tastes. Maurice Quentin de la Tour was one of the greatest pastel portrait painters of the century. Such was the success achieved by this technique that the academy forbade any pastel painter to enter its ranks, so that the oil portrait would not be threatened.

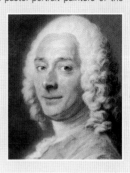

Maurice Quentin de la Tour, Portrait of Monsieur Duval de l'Epinoy (detail), pastel. Caloustre Gulbekian Museum, Lisbon.

the object of the work. It is not strange that Ingres should have said: "To express the surfaces of the human body it is first necessary to control its structure." During the eighteenth century, nudes and portraits of startling realism were painted. Thanks to rigorous study of the body and its internal workings, the refined understanding of human musculature elevated the nude as a visual theme. Figures were represented with volumes and changes of tone that expressed the physical reality of being. A sophisticated understanding of anatomy, as well as the pictorial understanding of flesh tones, was represented by means of every possible technique.

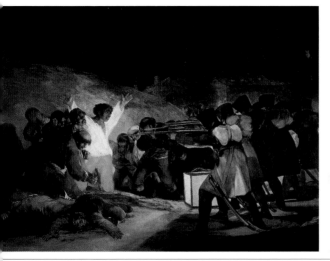

Francisco de Goya, The 3rd of May 1808. The execution of the defenders of Madrid, oil on canvas. Prado Museum, Madrid.

PAINTING IN THE NINETEENTH CENTURY

The nineteenth century is the century of Realism. It is a realism that has left behind it the decorative customs of classical Italian composition and the passionate dynamism of Baroque painting. The painters of this period were interested in real facts, and for them, light and dark were part of this reality. Chiaroscuro is not an excuse for being dramatic, but a way of representing the truth. Objects are defined in all their weight and volume, and light has to be represented naturalistically. From this desire for realism would be born Impressionism.

Realism: The Study of Light in Courbet

Courbet's realism coincided with the development of the first workers' movements of the middle of the nineteenth century.

Courbet used a thick, heavy technique, in which he included strokes of black pigment to reinforce the strength of his works.

Although the preoccupations of this great artist have a distinct political flavor, his color, light, and composition are central to his works.

Courbet's pictorial work is influenced by a pure, linear style, although this does not dominate, but rather combines with the perfect balance of line and color. *The Artist's Studio* is a clear example of taking reality just as it is, without idealizing or dramatizing it. Courbet paints things as they are, and as they are seen.

The Barbizon School

The artists of the Barbizon school, lovers of rural life, were concerned with representing the beauty of the natural landscape, which was their only subject. Climatic conditions in these scenes were the deciding factors for the coloring of their paintings. Many of these works depict sunsets, illuminated by the pinks and oranges of the sky, contrasted with the greens of the fields and trees. Landscapes continued the chromatic investigation of light and shade based on observation. There was no attempt to consecrate nature as in the Romantic period, but rather to study it. Impressionist painters inherited many characteristics from the landscape schools, although they gave fresh importance to brush stroke as the way to capture reality. Themes changed and while these artists also painted rural scenes, the human figure and street scenes took on greater importance. The Impressionists painted in the open air, but included many urban themes. When they were rejected by the official academies and salons, they formed their own groups and organized independent exhibitions.

Gustave Courbet, The Artist's Studio. *Louvre Museum, Paris.*
The representation of a daily scene in the life of the artist.

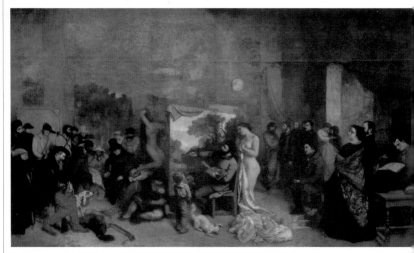

Academic Study
Painting in the Nineteenth Century
Painting in the Twentieth Century

19

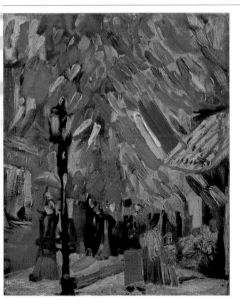

Vincent van Gogh, 14th of July in Paris. Jaggu Hahnloser Collection, Winterthur. This is a clear example of how brush stroke and color take precedence over line and modeling to depict form.

Understanding Light and Shade with Colors

Impressionist painting was based on direct sensations that objects evoked in the painter, and explored the optical effects of vision itself.

Under the influence of Impressionist theory, pictorial concepts began to change. The palette because limitless with no barriers to color. Primary and complementary colors alternated within the warm and cool ranges. Black and gray were given little importance within this new vision of the world, particularly regarding shading, which was now done by using complementary colors as well as concentrated areas of cool colors. Light was depicted using the light, warm colors.

Colorism Cancels Modeling

Impressionist painting developed into an explosion of chromatic vitality. The colors that are used are usually pure and clear. Formally the composition is implicit within an atmosphere based on brush stroke and color markings. Line and blending disappear completely. In these end-of-century works, the search for reality is based on first impressions, on the direct image that is projected onto the eye's retina.

The search for direct impression was the reason why all artistic activity was focused on capturing light and color in an immediate way. Figures began to be treated in the same way as the background, as the artist looked for chromatic relationships that could be established between them both.

Up until this point artists had always sought to depict detail and composition very clearly and correctly in order to more closely portray reality, and works required a great deal of patience and observation in order to be correctly considered and created. With Impression-

ism was born rapid painting, as painters discarded conventional wisdom and focused on the execution of brush strokes that were free and dynamic, creating the painting's rhythm and composition. Colors became pure and light, using contrasts of complementary colors. Chiaroscuro loses importance in the chromatic interplay that is established between the cool and warm color ranges characteristic of Impressionist painting.

Eduard Manet, Argenteuil (detail), 1874, oil on canvas. Museum of Fine Art, Tournai (Belgium). In this work one can appreciate the beauty of the study of light in open air painting.

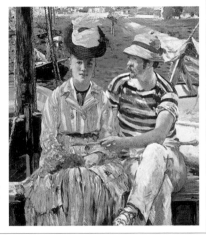

PAINTING IN THE TWENTIETH CENTURY

Following the Impressionist revolution, pictorial archetypes changed increasingly quickly. Painters distanced themselves from any rules and looked for new forms of expression entirely divorced from any type of former teaching. Art became a form of thinking, a medium to express ideas, and it adopted a rebellious attitude toward established rules and morals. This is characteristic of the way avant-garde movements are born, as revolutionary philosophical movements.

Art in the twentieth century is characterized by its symbolic nature, and the artistic rules of perspective and the study of volume are subordinated to the message and significance of the work.

Light and Shade in Expressionism

Expressionism is a dominant tendency in the art of the twentieth century. Born in the first years of the century, it was developed further in the vibrant colorist aesthetics of painters such as Gauguin and van Gogh, who worked in strong, energetic colors and tonalities. In Expressionist paintings, problems of light and shade are resolved using approaches that are very different from the traditional, realistic styles before them.

For Expressionist painters, light is created from the powerful use of color. Shadow does not follow the exact form and shape of figures and objects, but is used to intensify chromatic contrast instead. Thus a figure may be defined by intense extremes of local color (bright yellow, if it is yellowish in tone, even saturated red if the subject is

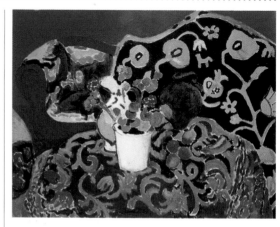

Henry Matisse, Spanish still life, *1911, oil on canvas. Hermitage Museum, St. Petersburg. The concepts valued by the Fauvists would be taken up by the Expressionists.*

reddish and so on). Shadows are often painted with complementary colors: violet (the complement to yellow), green (the complement to red) for example. This way of working requires a drastic simplification of line, and for this reason

Expressionist works are usually characterized by dominant linear schemes and lack of realistic spatial grounding, due to the absence of light and shade. Within this general, stylistic framework, the artists of the twentieth century investi-

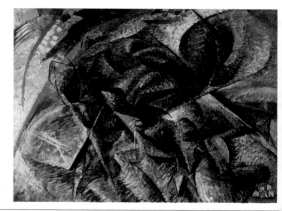

Umberto Boccioni (1882–1916), Dynamism of a cyclist, *(1913), oil on canvas. Private collection, Milan. The work is representative of the avant-garde movement known as Futurism, an heir to Cubism. Planes of light and shade alternate with the interplay of color in this composition.*

Painting in the Nineteenth Century
Painting in the Twentieth Century
Shadows and Light Direction

21

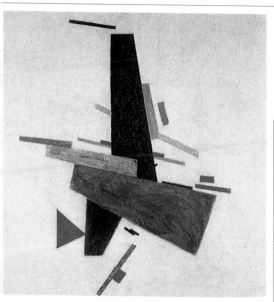

Kaximir Malevich, Suprematist Composition, 1915, oil on canvas. Peggy Guggenheim Foundation. The avant-garde painters were the first to overcome the imposition of the interplay of light and shade.

Photographic realism is a movement that came about as a reflection of contemporary society. Art has returned to pure line and perspective, and images of the times and culture the artist is surrounded by.

In photorealistic painting color is as important as line. However, unlike the painting of the Expressionists, there is no more color than in reality. There is no longer a subjective means of observation, but rather the artist is totally objective, as a photograph can be. The study of light becomes important once again.

Light and tonal gradations towards shade are made by creating tonal values, avoiding the effects derived from the exaggerated use of color. There are no extremes or dramatizations of the theme. Nor is the light forced, but rather treated as just another element in the composition. The sensation of space and perspective are, once again, the center of the pictorial investigation.

gated new forms of dealing with the phenomena of light and shade, moving towards either extremely realistic methods, or in the opposite direction towards abstraction.

Light and Shade in Pop Art

Pop Art is an avant-garde movement that appeared in the second half of the twentieth century and is characterized by a type of representation that is profoundly influenced by mass communication media. "Pop" artists do not take reality as their starting point, but rather advertising, cinematic, and images generated around consumerism.

In many Pop Art images flat areas of color may be combined with the use of fine drawing. The eclecticism of these works of art makes it difficult to define the use of light and shade. When the artist uses flat areas of color to define figures and objects, shade must be represented in flat areas as well. The use of flat color areas is a very different approach than an orthodox treatment of

chiaroscuro used in realistic drawing and painting.

Light and Shade in Photographic Realism

Photographic realism is one of the last painting movements of the twentieth century. After long years of discarding form, artists once again opted for representing reality realistically, a realism highly influenced by modern photography.

Current Movements in Painting

As painting has evolved in the twentieth century, the style and the plastic and aesthetic intentions of art have expanded. Formerly art was based on collective ideas, and its theories and principles extended to all aspects of culture, which were reinforced not just by artists, but also by great philosophers and thinkers.

However, as art has evolved, it has produced an individuality that makes it difficult to evaluate and classify. One can only agree or disagree with the vision that a work presents. There is, however, a tendency toward a minimalist style, which aims to express the maximum information with the minimum number of elements. This tendency began as a development of abstraction and became a movement in its own right, not only in the field of painting but also in architecture, sculpture, and the new plastic arts derived from the most modern technologies.

SHADOWS AND LIGHT DIRECTION

Light makes objects visible and determines the shape and intensity of shadows. The following brief summary of the essential characteristics of natural and artificial illumination, as well as the different possibilities for illumination, will demonstrate that light and shade are elements that are inseparably linked. The form and volume of visible objects comes from the differing distributions of light and shade on their surfaces.

Natural Light

All light sources emit rays or beams of light in a radial direction, spreading in all directions from the light source. Because of the enormous distance between earth and the sun, natural light, though it radiates, appears in parallel beams. As a result, the shadows it casts are always parallel with one another, regardless of the position of the objects being illuminated. Since natural light cannot be controlled as can electric light, the artist working in the open air painting themes such as landscapes and seascapes must choose a particular time of the day and resolve questions of light with a certain speed. Anything that can be worked on in the studio can be resolved later.

Light is elemental in the depiction of the illusion of the three dimensions of a surface. Modeling, as the process is called, compels the artist to careful study and analysis through the use of observation.

Full-frontal light,

Frontal-lateral light,

Lateral light,

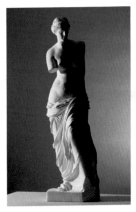

Back light,

Top light,

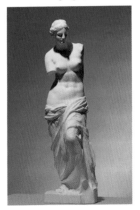

Light from below.

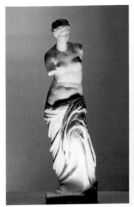

Painting in the Twentieth Century
Shadows and Light Direction
The Study of Light on Simple Elements
23

Projecting Shadows

Light is a compositional element, and therefore may be used within perspective to banish its most obvious feature, shadow. Shadow is projected onto different elements and planes in the composition when the light falls upon the objects within it. Shadows fall upon planes, vertically, horizontally, or diagonally, recreating the shapes of forms and figures where they are cast.

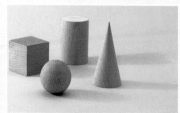

However, if the shadow falls on another element, it will be distorted, conforming to the shape of the second object.

Shadows projected onto an object here follow a horizontal plane, and do so continuously until the horizontal plane becomes a vertical one. The shadow is broken by changes in the plane, either a wall or another object. An object's own shadow does not vary if light conditions stay the same.

Artificial Light

In a room lit by a single artificial light source, the radial nature of the beams of light that are emitted can be easily observed: the shadows of objects are cast in different directions, depending on the positioning of each of these objects. Artificial light is easily controlled by the artist, both in direction and intensity. The shadows of a subject being illuminated by artificial light can be modified by adding additional light sources to reinforce or counteract certain shadows. Indirect illumination can also be created by altering the location of the spotlights.

The Direction of Light

Light as a compositional element can be controlled so that it generally enhances the work, something that the artist should always bear in mind. Light is already defined according to the direction from which it comes: front, top, lateral, front-lateral, back, or below.

Lateral light illuminates the model from the side, casting the opposite side in shade. This type of lighting was used during the Baroque period for added drama.

When talking about frontal light, it is necessary to distinguish two different types: the first is light that strikes the front of the model directly. This rather harsh form of illumination produces little, if any, contrast of light and shade, making it hard to read the volumes and elements in the composition. This is full-frontal light.

The other type of frontal light is called front-lateral light, which always strikes the model at a 45° angle. The subject or theme is highly lit in some areas. The light undergoes gradations toward the shadow cast at the opposite side, until it reaches full darkness.

Top lighting comes from a source above the composition. This type of light creates particular effects, and may be used by painters of mystical or religious themes.

Lighting from behind leaves the area of the model closest to the viewer in shade, creating quite another feeling.

A light directed from below a subject tends to create a theatrical effect similar to stage lighting.

MORE ON THIS SUBJECT

· Composition and Shade p. 30

The difference between natural light and artificial light becomes clear when we look at shadows. Shadows caused by natural light are parallel to each other, whereas those that are caused by artificial light are radial.

THE STUDY OF LIGHT ON SIMPLE ELEMENTS

Light is directly responsible for the appearance, shape, and color of objects. The light spectrum in its entirety contains all the colors we can see. Light illuminates all the volumes of the three dimensional world. It reveals its composition of planes, which appear closer or further away depending on the amount of light that reaches them.

Light and Shade on Flat-faced Objects

To introduce the study of light and shade most simply, one might consider regular geometrical bodies that are solid, with flat planes, such as cubes or tetrahedrons (pyramids). The common characteristic of these bodies is that their surfaces or faces are clearly limited by edges. Because these objects are somewhat simple, we can illuminate them and observe the shade that is created. We can see the light and shadow distributed over their surfaces with much greater clarity than is usual in objects in nature, or those that surround us in our daily lives.

In effect, on a cube that is illuminated from the side, one face (the one that is oriented most directly towards the light source) will be much lighter than the others. More importantly, this face will have a fairly uniform tone, without any transitions from light to shade. This face reads as a pure plane of light. The other faces (the other two visible faces, since you can not see more than three faces of a cube at any one time) will have differing degrees of shade. Under normal conditions, the upper face will be less shaded than the side face. When you represent these three planes of light with pencil or charcoal (with one face well illuminated and two faces with different

light intensities) using shading, you can achieve the sensation of relief, the three-dimensional appearance of the form. In this way, in drawing and painting, the representation of light and shade is the means by which the artist can express the three dimensions of objects in space.

From the above example, it is easy to understand that any object or surface is a combination, more or less complex, of different planes of light. One can also see that when these planes of light are represented in a drawing or painting, it is possible to create a convincing imitation of form and volume. Each of the zones of light and shade, whether they are small or large, has a tonal value. A tonal value is a particular

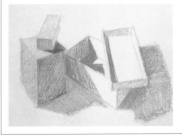

A good practice exercise is to represent elements with flat planes. Any shoe box or other rhomboid object can help you understand the shadows that are projected onto one or more planes. (Miquel Ferrón.)

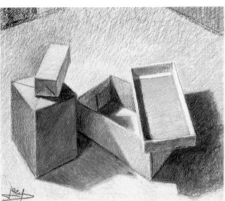

Shadows and Light Direction
The Study of Light on Simple Elements
Light and Shade in Sketches

25

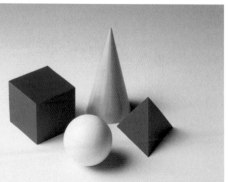

It is a good idea to have basic shapes on hand, so that you can practice daily in order to achieve a better understanding of the effect of light on these forms. This is a basic exercise for experimenting with different techniques before studying more complex forms.

ntensity of shade or light. ssigning a tonal value to an bject is nothing more than epresenting its shape and utline using shading.

Shading gives an object tonal alue, depicting its volumes in ones that correspond to the alues observed.

ight on a Cone nd a Cylinder

Cones and cylinders are andled in similar ways, as oth have a circular base. When a shadow falls on either f these two volumes, it moves om light to dark gradually as t wraps around the form, from he point of most light to the darkest point, if the light source s diffuse. If, on the other hand, he light source is direct, you vill notice how the change rom light to shade is very brupt, and is marked by a erfect line.

ight on Spherical Objects

The sphere is a unique ele-nent in geometry. Spherical orms can really only be depic-ed in three dimensions by sing carefully rendered effects of light and shade. Otherwise it would appear only flat and circular.

When a sphere is depicted, it should always be done by means of the shade created by a source of light as well as by the decoration it might have on its surface. The light will be centered on a concrete point, darkening as it moves away from this point. If the light comes from the front, the sphere will appear as a circle, without volume. If the light is lateral, or front-lateral, the shade will gradually blend toward the side opposite the light source. In contrast, if the lighting is direct, the shade will stand out cleanly on the sphere's surface, in the shape of a crescent moon, depending on the direction of the beams of light.

Exercises in Light and Shade

Paul Cézanne said, "You should treat nature in the same way as a cube, a sphere and a cylinder." The truth of these words is that everything in nature can be reduced to one or more geometrical forms that help the observer to under-stand what he or she is looking at, in order to transfer it to paper or canvas.

For this reason it is a good exercise to practice with these volumes, using variations of light and shade, placing them in different positions. Initially this can be done with each object separately and later in compositions of more than one object.

Begin with a monochrome study using charcoal on white paper. Once you have mas-tered the volumes, you can go on to a color study.

MORE ON THIS SUBJECT
· Light and Shade in Still Life p. 36

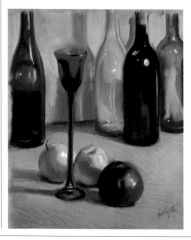

Still life paintings generally contain simple forms, especially if they include spherical fruit and cylindrical elements such as bottles or glasses. This painting was done in pastel by Vincenç Ballestar.

LIGHT AND SHADE IN SKETCHES

Drawing is the best medium for studying light and shade in any subject or theme. Drawing techniques are based on tonal values and tonal gradation using one or very few colors, so that the gradations of light and shade can appear with much greater clarity. Tonal gradations are the usual way of creating tonal values in a drawing, and consist of intensifying or reducing (grading) the intensity of a tone. Each drawing medium offers different possibilities for tonal gradations.

Hardness and Intensity of Shade

In any scene there are a series of relationships between light and shade that determine the representation of the subject. The initial stage of a drawing consists of establishing the first level of the image using lines and outlines, making an approximation of the calculation of proportions and the establishment of composition and balance of forms. The second level is comprised of the task of applying color and tonal value.

In this stage all the tones that convey depth, volume, as well as surface details of the scene, are applied. The intensity of the light source or time of day will determine the tonal range that is employed. When working in the open air, the effects of light and contrast will be entirely determined by the light of the sun, in which case it is necessary to understand the intensity of this effect.

In artificial conditions, the phenomena of light follows the same pattern, although in this case the artist can manipulate the intensity and direction of the light source. One or more spotlights can be used to study volumes, and can be moved closer or further away from the subject or model, depending on the amount of contrast desired. A closer light source will produce a greater intensity of shade than one more distant, which will soften the light effect, in the same way that the rays of the sun are softened by clouds. A strong spotlight can be used to create stark lights, while casting strong shadows. The use of a single spotlight will create a clearer and more obvious effect of contrast than having several light sources, which will produce multiple shadows, causing the effect of volume to be more confused.

Blending Tones

Blending can be done in different ways, and is often part of the personal style of each artist in achieving certain effects. Soft techniques, such a

One of the most useful exercises for analyzing grays is to depict a simple object, such as an item of clothing or a crumpled sheet of paper. In these examples by Jordi Segú, various planes are produced, which, through their position with respect to the light, will produce different tones of gray.

The Study of Light on Simple Elements
Light and Shade in Sketches
Light and Shade in Painting

27

harcoal or chalks, require the se of a cloth, a paper stump, or ie artist's fingers in order to lend one tone with another. he use of a cloth is ideal for reating a general atmosphere ut not for producing sharp ontrasts or more intense alues, as it removes a lot of the igment. Using a paper stump r one's fingers is best for roducing more localized or ore intense blending, as it resses the pigment onto the aper in a more consistent way, reating darker blacks and rays. With wet techniques, uch as washes, the order of stablishing tonal values can ary. Some painters prefer to dd color carefully, going from ght to dark. However, a uicker and more spontaneous iethod consists of reducing ie strength of the color with rater the closer it gets to the reas that needs to remain ghter. As for line techniques, ot only is it possible to create alues using cross-hatching, ut it is a good idea for each troke to follow the volume of ie object being represented, o that the three-dimensional ffect appears more realistic.

Charcoal is one of the most flexible techniques available, as it can easily be erased either with the fingers, a cloth, or an eraser, and can always be added to or retouched. (Exercise by Ana Manrique.)

Range of Grays

The use of a range of grays lepends entirely on the light onditions surrounding the ubject. Light conditions vary reatly, even when making nonochromatic works. Strong ontrasts demand the use of ones that differ markedly from ne another, grading in value oward both extremes of black nd white. In a composition sing strong contrasts, the half-ones are always close to both xtremes, and intermediate rays either barely appear or lo not appear at all. In the case f soft, atmospheric scenes, the ituation is completely dif-erent. Maximum tones might ot appear, so that black and vhite disappear from the tonal ange and all the tonal values

are centered around inter-mediate grays that vary in intensity from light to shade.

A Base for Studying Areas of Light

In any representation of reality, the first step is always a visual assessment and analysis. No mark should be made on the paper until the subject has been examined, the rela-tionships of the form have been understood, and the tonal values between each of the parts have been established. As for the study of tonal values, one very common trick, used by many artists, is to half close the eyes so that form and line disappear, leaving only general blocks of color which show the volume and make the tone changes clear. This overall vision of the subject allows the

first areas of color to be placed on the paper, describing the volume in a very basic way. The tonal foundation is laid by first blocking in the maximum contrasts, then adding the half-tones. The details will be incorporated progressively as the work is developed. With careful observation it will be possible to represent the smallest variations of tone occurring in very localized areas, which will help achieve a realistic result.

MORE ON THIS SUBJECT

· Drawing Media p. 48

Opening up light areas depends on the color of the paper. White chalk can be used to create light tones. (Work by Jordi Segú.)

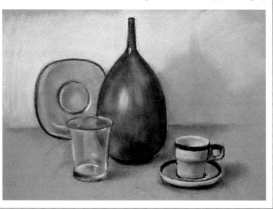

LIGHT AND SHADE IN PAINTING

Establishing areas of light and shade in a painting follows the same principles as for a drawing: through tonal values and tonal gradation. But painting also introduces the question of color. Now the artist must consider the way brush strokes are used to create the effects of light and shade as well as the application of color and the contrast between adjoining tones. These questions, in addition to questions relating to creating the effects of lightness and darkness in color using color mixing, are the subject of this chapter.

Tonal Values in Painting

In painting, as in drawing, it is necessary to locate and shade the planes of light and shadow, the tonal values of the theme. In painting, the process begins with a general coloring, which indicates the areas of light and the areas of shade, as well as the intermediate tones that fall between them. Light and dark tones should be established using a restricted color range which, in most cases, can be limited to a couple of tones.

Whenever powerful dark or light tones are depicted, one always follows the law of simultaneous contrasts: "A light

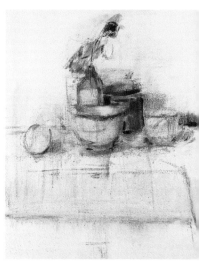

Pere Mon makes an initial sketch with a paintbrush loaded with little paint, approximately locating the first shaded areas.

In the second instance the artist begins to place the light tones, beginning with the ones at the back and then passing to the principal motifs. The definitive shading has not yet been completed.

Once the shaded areas have been painted, the artist can add the details. Blending effects can be achieved by working wet-into-wet. It is also possible to use a spatula to apply impasto over large areas. The work is finished off with the highlights and shade.

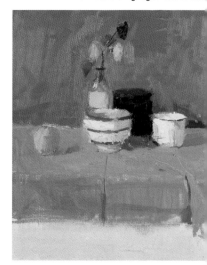

Light and Shade in Sketches
Light and Shade in Painting
Composition and Shade

29

olor is lighter the darker the olors are around it, and vice ersa." For this reason whenver you want to depict an area f shade, you should lighten the ones next to it, and conversely, arken those parts that are ound around a highlight. Be areful not to make the mistake f most beginners, which is to pply white highlights in the luminated areas, and black to he dark ones. In each painting here exists a particular chromticism or coloration, and within hese colors, both light and ark, there are tonal ranges hat you can follow without aving to weigh down the ainting with heavy blocks f color.

When using opaque media, ou can work on dark areas y superimposing layers and dding highlights at the end. When using transparent media, uch as watercolor, areas of ight must be reserved from the eginning as they can be made arker, but not lighter.

Direct Painting

Direct painting is perhaps ne of the most difficult techiques that exists. It consists of painting without making an nitial study. The study is the work itself, and the artist thinks nd resolves problems as the

MORE ON THIS SUBJECT
· Complex Shade with Watercolors p. 82
· Expressing Light with Oil Paints p. 86

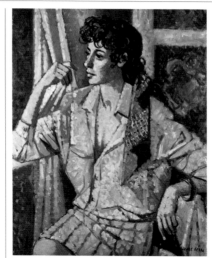

Sometimes the development of marked brush strokes and the use of textured paint can create an alternative way of showing volumes and contrasts. The result avoids using uniform surfaces to show the interplay of vibrations between light and shade. (Work by Manuel Ricart Serra.)

work develops. This method of painting is best for media which, like oil paints, allow for easy correction. Such media take some experience to handle.

When painting directly, a light sketch of the subject is done on the canvas or support, which is then colored directly with the colors that appear in the subject. The work can then be retouched once the first underpainting or scheme of overall color has been made.

In this technique the depiction of both light and shade is made directly, to achieve an immediate effect.

Using the Paintbrush to Apply the Paint

The paintbrush is the painter's most useful tool for creating a visual representation. It is used

to model and create surfaces. Brush strokes give color and volume to forms, following the direction of their lines and surfaces.

The best brush stroke to use depends on the medium. There are two types of fundamental brush strokes: dry and wet. Dry brush strokes mark the surface, while wet strokes slide the paint over the support and create effects such as blends.

By going over the same area of a painting several times with a paintbrush, using a lot of paint, the paint may be spread homogeneously and smoothly. Paint can also be applied in very fine layers with a fine brush, leaving no trace or texture. This creates a highly refined image, leaving a smooth, satiny finish on the canvas.

Instructive examples of how to achieve light and shade using simultaneous contrasts. In figure B you can see how by darkening the area next to the bright highlight, it stands out more and seems to be even more emphasized.

A
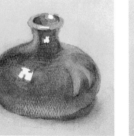

B
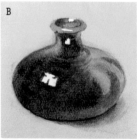

COMPOSITION AND SHADE

Shade is an excellent starting point for the composition of a drawing or painting. Before considering the shape and size of objects, it is necessary to resolve the distribution of light and shade in the theme, as this distribution coincides with the arrangement of its different volumes. Creating a composition starting with shaded areas can be done by first applying dark areas of color, then refining them until they depict the outlines and details of the subject or theme.

Distributing Objects and Shade

To create a painting it is not always necessary to depict everything that you can see. Instead you can make a choice. Depending on the aim of the work, you have to know what is necessary to the composition and what is irrelevant.

It is necessary to find all kinds of visual contrasts, or in other words, to oppose straight forms with curved ones, small ones with large ones, hard objects with soft objects and of course, light with shade.

All paintings should have a protagonist, a main figure that becomes the theme of the painting, and this must be clear enough to attract the attention of the person or people who are looking at the work.

Whenever you compose a work, you should be careful that larger objects do not hide smaller ones, as otherwise the composition may lose impact or be confusing. The effect of one

The Weight of Shade

Do colors have weight? This question may sound silly yet we know that we perceive colors to be light or heavy. Light colors are colors that transmit lightness and lack of weight, while dark ones have the opposite effect.

Ricardo Bellido places the larger objects in the background in order to set up a strong, airy space. Though the maximum amount of shade falls on them, they do not hide the localized color of smaller objects.

object upon another must also be considered, for instance a large object throwing its shadow onto a smaller one may obscure it or make it hard to represent.

If you aim to depict several objects in the composition, the largest and most familiar forms should be placed in the background, while the smaller ones should be placed in the

The same object lit from the side highlights the different planes, as some of them are lit and others are not. The localized color is given nuance by tonal variations.

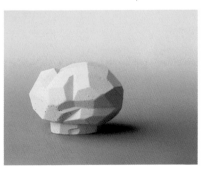

By illuminating an object from the front, you can observe that very little shade is produced, which makes the localized color of the object stand out.

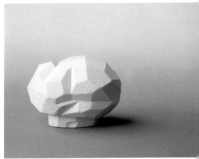

foreground, so that the field of vision gains depth.

Balancing Weights in a Painting

To distribute the weight of a painting, or in other words to balance a painting chromatically, it is necessary to use the weight of color. As dark areas are heavier than light ones, they should be less extensive in area. This means that if you had to balance a red area with a yellow area, the yellow would need to be much larger than the former, since the color red is heavier than yellow, since it is darker.

The Importance of Shade in a Composition

In order to create a work of art it is necessary to take into account the whole composition. Once the values of the subject as a whole have been studied, and the artist moves on to the composition, the steps that must be followed are always the same, and the role played by shade in a figurative composition is very important.

The first step is to block in the forms. Many artists choose to make a linear sketch and then to move on to a study of light and shade in order to establish the volumes. Others go directly to this second step, although it always depends on the experience of the artist and on the subject matter to be depicted.

Shade is a helpful way of understanding the compositional whole. It is shade that determines the volume of a subject, depending on the type of light that falls on it.

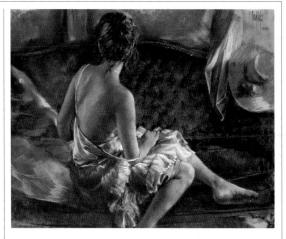

The human figure lends itself to hundreds of nuances of light and shade. In this work by José Luis Fuentetaja, the figure stands out from the shade of the rest of the composition. The cushions and the dress also stand out against the shade with extraordinary brilliance.

Shade occurs in relation to the direction of the light. This is a phenomenon that can be verified by observation, yet shade never occurs in quite the same way. In a still life, for example, shade is thrown onto horizontal and vertical planes, as well as onto the different objects that make up the composition. Shadow deepens progressively as one moves toward the background of a composition. In a landscape shade behaves differently, assuming endless forms and nuances depending on the direction, color, and diffusion of ambient light. Shade can be part of a foreground, then alternate with areas of light, progressing to the line of the horizon, before opening up into a completely diaphanous sky.

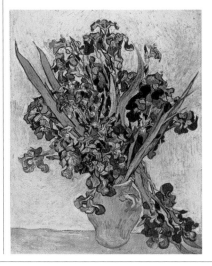

*Vincent van Gogh,
Vase with Flowers.
Rijksmuseum, Amsterdam.
An astounding way of visually balancing a totally asymmetrical composition by using blocks of color.*

MORE ON THIS SUBJECT

• The Study of Light on Simple Elements p. 24

REFLECTIONS

The phenomenon of the reflection is perhaps one of the effects that has most drawn the attention of artists over the centuries, along with the mirror effect, the world seen in reverse, the extension and increase of space or the sensation of depth. However, the greatest technical problem for the artist consists of how to achieve the representation of shine and reflection of glass, metal, and other materials that react in their own particular ways to the action of light.

Reflections and Metallic Highlights

Whenever we consider highlights and reflections in painting, we must remember that the treatment of these light phenomena varies depending on the technique that we want to use.

Reflections on a metallic surface can be of two types, depending on the nature of the reflective surface. A totally polished surface will reflect a clean image of objects close to it, while a rough metallic surface, or one that is not very highly polished, will reflect a very undefined form.

Highlights on metallic surfaces are what are known as spot highlights, since on a metallic surface, polished or not, the light is concentrated in a point, and is projected onto the viewer's eye in such a way that it almost seems like a spotlight shining from inside the painting.

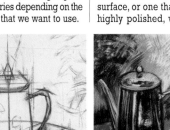

MORE ON THIS SUBJECT

· Light and Shade in Still Life p. 3.
· Highlights and Shine Using White p. 54

The technique of airbrushing allows the artist to produce depictions of metal surfaces with great precision. In this work by Miquel Ferrón the highlights are like small clouds of white applied onto key points of the object. This effect should not be overused, though, as the object would end up blurred.

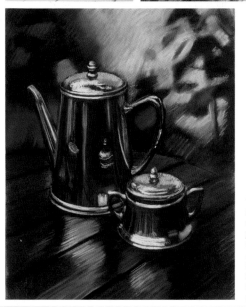

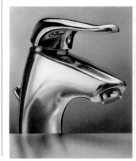

The resolution of a theme of metal objects is based on the constant contrasts that are established between the maximum light points and the shaded areas. The technique of using pastels requires the artist to apply the highlights precisely and cleanly once the rest of the coloration has been resolved and the blacks are sufficiently intense to provide maximum contrast. (Exercise by Joan Sabater.)

Reflections in Water

The depiction of water is a commonly featured element in painting: a glass of drinking water, a river, a lake, the sea, the ocean, a puddle, or even a rainy landscape.

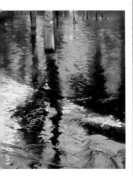

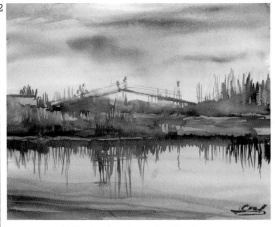

Reflections in water can be of two types:
1. The scene of a river painted in pastels. The shimmering effect of the river has been achieved by blending. (Work by Vicenç Ballestar.)
2. An undistorted reflection on quiet waters. (Work by Miquel Ferrón.)

Like metal, water can show two types of reflection: one sharp, one blurred. The clearest reflections can be seen in lakes and puddles. For one thing there is enough water present to create reflections, and for another, still water acts as a mirror.

This is not the case with rivers, and still less with the sea, where the phenomenon of reflection is minimal, and reflections are very diffuse, since the water is in a state of continual movement. With rivers, there are sometimes stretches where the flow of water is more gentle, in which case parts of the surrounding scenery can be seen faintly reflected in it.

Reflections in Glass

Glass can be a highly reflective surface, provided that light conditions are right. Glass can be of many different types. Textured or etched glass does not produce the right conditions for reflections, but smooth glass, again, if the right conditions exist; tends to reflect proximate objects. There is also smoked glass, which acts almost like a mirror, providing a perfect reflection in almost all light conditions. Other types of glass that range from transparent, to milky, to painted, and glass that has been stained while still molten.

The representation of glass brings with it the problem of creating a surface that is solid and at the same time transparent. The secret lies in the small differences in light and shade that can be seen when carefully studying a glass receptacle. It is these differences that, when added to the highlights, will create the sensation of transparency that can be so problematic for the inexperienced artist.

Transparency

On objects made of glass, the phenomenon of shine is also associated with the transparency of an object. Highlights are areas that reflect on a surface that would not read in a visual representation if not for these details. But any object made of glass shows slight variations in light and shade, in the same way as an opaque surface, permitting the representation of their volumes.

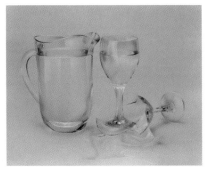

A work by Miquel Ferrón of photographic realism, painted with an airbrush. The glass surface creates a reflection of the metal faucet, depicting its surface, following its curve.

TEXTURE ACCORDING TO LIGHT

What elements make it possible for us to recognize something? Marks that convey form, volume, size, color, and the details a material is made of. The representation of the surface of an object gives the viewer the information needed to situate it in the equation of space and time. Objects made of clay, metal, glass, and cloth have to be represented in convincing ways. Two objects of the same shape and size, made with the same material and the same color, will need to be differentiated, for instance, when one is older than the other. When light falls on both objects, it will show two objects that must be represented with characteristics that are similar, but not identical.

Shadows and the Surfaces of Things

The faithful reproduction of surfaces is almost an obsession for some painters, since it is at this precise point that their skill is called into play. The beauty of flesh, the coldness of metal, and so on are characteristics that give the viewer the most information, so it is not surpris- ing that realist painters should be concerned with them.

Each object has characteristics that are intrinsic to the material of which it is made. The light provides a wealth of information as it falls upon a surface. It strikes objects in such a way that we can appreciate the changes in their textures, since the human eye is capable of distinguishing such minute details. The light falls on these textures and creates a particular interplay of light and shade that reveals the nature of the object's surface, in such a way that it becomes recognizable.

MORE ON THIS SUBJECT
• Reflections p. 32

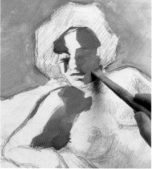

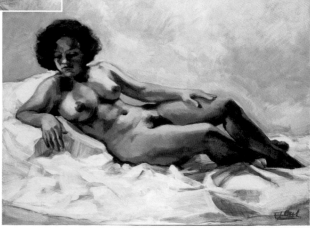

Human skin is a textured surface that changes with the light. The artist begins by establishing the more general shaded areas. The textures sur- rounding the figure are important to develop as well since the light of one affects the other. The skin presents a series of reflections, causing its tones, values, and nuances to change. (Exercise painted by Miquel Ferrón.)

Vicenç Ballestar resolves the short coat of an animal using a treatment of contrasts and by dragging the brush stroke.

The way in which the composition is illuminated can help or hinder the depiction of these textures, so the artist should consider various factors. A light that illuminates a composition intensely can hide the roughness of a clay object, but can accentuate the shine on a polished surface.

Bright Objects and Textured Objects

When the artist is choosing a subject to paint, it is always a good idea to think about whether the results will be aesthetically more agreeable and dynamic for the viewer if the textures are mixed, in the same way as when he or she is combining different forms.

There are two basic types of texture, smooth or shiny ones, and textured or rough ones. Shiny surfaces such as metal, porcelain, lacquer, glass, and so on reflect more light.

Rough or textured surfaces are illuminated but do not produce any highlights, since they are matte in finish. Textured surfaces include cloth, including shiny ones like silk,

human skin, or fired clay.

Inexperienced artists may well be challenged by the task of representing fabric in paint, as material tends to have a fluid form, adapting itself to the surface it covers, or following the pull of gravity when it is hung up. Conveying the textures of fabric may also be challenging, but ultimately helpful in presenting it in a convincing way.

Often an artist will chose to endow different types of surfaces with different degrees of pictorial weight, in order to produce a more realistic work, although this resource is more commonly used with opaque media than with transparent ones. This means that the representation of a textured surface may take more painting, while a shiny surface may demand a lighter, smoother handling and less detail to be convincing and function well in a composition.

Glazed ceramic objects that show highlights can be conveyed by locating lighter colored objects and surfaces around them.

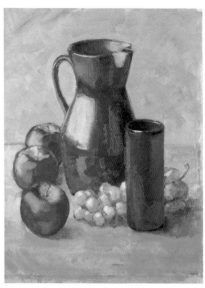

The texture of the glass is achieved using direct, white highlights, in such a way that it expresses both form and material. (Work by Miquel Ferrón.)

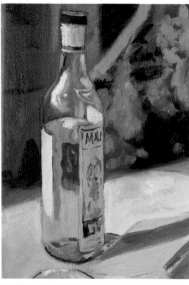

LIGHT AND SHADE IN STILL LIFE

The still life is highly suited for the study of lighting and for putting into practice the concepts associated with it. Unlike, say, a landscape, the artist can manipulate the subject, adding or removing objects, changing the direction or intensity of the light, and modifying the theme at any stage of the work. By studing the objects of a still life the artist can come to understand the basic principles that govern a composition as expressed in terms of its light and shade.

The Model and Lighting

The key advantage of the still life is that the artist has so much control over the elements of the painting. Ordinary, everyday objects such as fruit, vegetables, clay jugs or wooden bowls, have warmth and charm. Adding an attractive cloth or napkin can add a rich touch to the composition.

When painting still life for the first time, it is best to choose simple elements, and not to overburden the composition. Two or three simple elements are enough for a full composition to which you can add other objects later on, when you have gained more practice.

Once you have chosen the subject and the medium or technique you want to use, it is important to determine the type of illumination you want to work with. The light should enhance the subject matter. The use of lighting depends on the artist's aesthetic. Artificial light is easily manipulated. Natural light can be directed to some degree by means of a window or door.

If using artificial light, the artist is free to choose the color and strength, as well as the direction of illumination which will best serve the composition.

The Process of Shading a Still Life

To understand and correctly apply shading in a still life (whether in a drawing or a painting) it is necessary to study its objects and differentiate the degrees of shade

1. Francisco de Zurbarán (1598–1664), Lemons, oranges and roses. Norton Simon Foundation.
2. Paul Cézanne (1839–1906), Still life, Museum of Modern Art of New York.
3. Henri Matisse (1869–1954), Still life with harmonium. Private collection, Paris. Each of these still life paintings is representative of a period of art history. As you can see in Zurbarán's painting, the design takes primacy over the coloring, and offers a progressive change in tone. Paul Cézanne balances design and coloring, achieving volumes that are expressed through a strong contrast between black and the surrounding tones. Matisse's flat color scheme completely negates volume; rather the objects are defined by their outlines.

1

3

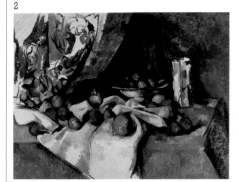

2

Texture According to Light
Light and Shade in Still Life
Light and Shade in Landscapes

37

on their surfaces. Notice the areas corresponding to the brightest areas of light and the darkest areas of shade as well as the main intermediate values. Imagining an objective scale of values can be a helpful tool for organizing the composition tonally. The key to identifying the areas of significant values, the ones that most strongly contribute to the representation of an object or space, lies in comparing each tonal value with the others.

Blocking In Tonal Values

Ideally, when shading a still life or any other subject, one does not need to outline the forms by simple line. Blocking in the tonal values of the graduated light and shaded areas, using corresponding grays, creates the limits between the different volumes. These limits are none other than the outline of the drawing, or its sketch. We say ideally because it is almost impossible to begin representing the elements of a still life without a rough sketch of the outlines of the objects, no matter how simple.

A common error is to mark out the outlines of the shape once you have finished establishing the light and shaded areas of the still life using blocks of color. Doing this will have the effect of flattening the volumes. If the values are incorrectly represented, the added outline will distort the result even further. For this reason, it is best to avoid creating a perfectly finished line drawing before applying blocks of color to a composition, since the lines will influence the task of applying tonal valuation.

Hard-edged Shade

Whenever a subject is lit by direct light, the composition will have strongly illuminated areas and those in which the

Surfaces and Shine

Whenever creating a study of light, it is helpful to remember that the appearance of light depends on the surface it falls on. A matte clay surface will have its own character as will a glazed, metallic, or enamel surface, the skin of a piece of fruit, or the leaves of a plant.

The complexity of a still life does not depend solely on the number of elements of which it is composed. The material they are made of can be problematic to represent, especially if they are very reflective or transparent. Glass is one of the most aesthetically appealing materials to represent and at the same time one of the most difficult to portray, as the light hits it in a very particular way. (Exercise painted by Miquel Ferrón.)

shade is very pronounced. When an object is directly lit, both its shade and its shadow will be hard-edged and clearly outlined. A shadow will throw its image on anything that stands in its way, whether it is another object or a wall. This is more readily seen in a composition containing simple elements. The shadow will always be a little distorted by the direction of the light and the form of the object it is thrown onto.

Soft-edged Shadows

Soft-edged shadows occur when the quality of the illumination on the subject is soft or diffused. This type of light is the natural effect of a cloudy day. It is also characteristic of the light that reaches the interior of a studio from a

somewhat distant point or an indirect light source, causing softer shadows. Soft-edged shade may not have a specific form, and various shadows might be thrown onto the same plane. Soft-edged shade can be depicted in various ways, depending on the type of technique being used. Here it is helpful to remember that not only can the artist obtain dark shaded areas by darkening the color of the background or the model, but color ranges can also be manipulated as can contrasts between warm and cool colors, to achieve the desired space and form.

MORE ON THIS SUBJECT

- The Study of Light on Simple Elements p. 24

LIGHT AND SHADE IN LANDSCAPES

On the subject of landscape, remember that we are considering the most practiced and respected pictorial genre that has ever existed in painting. Landscape is above all a three-dimensional composition, although there are also flat landscapes. The natural landscape is characterized by the reality that its light source is the sun, whose light can vary depending on the time of day, the season of the year, and the latitude of the country. In a warm country, the colors will not be very saturated, and in cold countries the tones will be concentrated.

Foregrounds and Shade

When creating a composition, it is important not to confuse the picture's foreground with its center of attention. Often the foreground is toned in a light to medium shade.

This light shade in the foreground allows the artist to locate the central focus of a composition that may fall in another plane, closer up, medium range, or distant.

The plane with the most focus, the central point of the painting, will need to be lighter, because lighter areas tend to attract the gaze of the viewer.

This is only natural, since the human eye discriminates between light and shade, perceiving shade in the background, behind the areas that receive more light.

On cloudy days, when the sky is overcast, the effect of shade disappears almost entirely and so everything appears as an evenly toned whole. In this work there is a lack of sharp delineations of light and shadow, the sudden changes of contrast that the sun normally causes to natural landscapes. (Work by Vincenç Ballestar.)

Softness in Distant Contrasts

Up until now we have considered the foreground and the planes with the most focus or importance in a work. However, there are a series of secondary planes in a landscape that give it the feeling of depth. These planes are those that are closest to the line of the horizon and the sky.

The sensation of depth is achieved by constructing the composition using various chromatic planes, the values of which are close to one another, in order to create a smooth gradation.

This type of technique, which the Italian master Leonardo da Vinci retrieved from antiquity, is also known as atmospheric perspective, and is achieved by means of the blending of forms and colors the closer they get to the line of the horizon.

Jaume Mercadé, The Fortress. Private collection. The planes closer to the viewer are neither the lightest nor the darkest. Notice how the middle planes of the painting are most sharply lit.

Light and Shade in Still Life **39**
Light and Shade in Landscapes
Shade in Urban Landscapes

Contrasts to Strengthen Planes

Even if a painter is a colorist, all the colors of the spectrum need not be used in a painting. A good painter knows how to make the most of a few tones to achieve the required effect. This idea is worth bearing in mind, particularly for new painters who approach the subject of landscape.

A landscape is neither resolved more strongly, nor is understood more fully, by the

J.M.W. Turner, Lucerne and Lake Geneva. *Private collection. Mist tends to give a feeling of great depth, as the contrasts are less intense beneath a covering of low cloud. Notice how the chromatic variation is softer the further away from the viewer it appears.*

Using planes of color to depict buildings as if they were boxes, with the light and the shade of the walls correctly located, it is possible to depict a village relatively easily. (Work by Vincenç Ballestar.)

use of more colors. Often, it is preferable to simplify tones existing in nature to improve a painting. A palette can even be reduced to three tones: light, dark, and neutral. This chromatic limitation helps to create a palette of colors that contrast to create a dynamic scene.

Paintings should be worked on as a whole, rather than as an accumulation of details. This applies when working on tonal contrast. It helps to begin with the background and build forward in space plane by plane. The artist can then create a balance in tonal and chromatic relationships and in the sensation of depth.

Camile Corot, Hagar in the wilderness. *The Metropolitan Museum of Art, New York. Chromatic contrasts are always dramatic and convey the effect of the sun falling on the natural landscape. Climatic conditions must be taken into consideration, as they can affect color as well. In spring or summer for example, as in Corot's painting, the chromatic contrasts are much more accentuated than in autumn or winter. These are the effects of nature itself.*

MORE ON THIS SUBJECT

• Painting in the Nineteenth Century p. 18

SHADE IN URBAN LANDSCAPES

The urban landscape as pictorial subject matter made its appearance during the Gothic period. However, during this era's early stages, painting lacked rational perspective, and the forms of buildings were shown as flat, and without vanishing points. During the Renaissance the urban landscape became an important and frequent subject particularly significant as a theme for the investigation of the laws of perspective. Nowadays, the urban landscape is also a favorite theme of painters. Its many representations depict the changes taking place so rapidly in modern cities.

Raphael, Marriage of the Virgin. Uffizi Gallery, Florence. A typical image from the Renaissance, in which imaginary, highly geometrical architecture provides the scene of a story. This painting represents a moment in which rational perspective has reached its peak.

Jaume Huguet, Altarpiece of the Saints Abdó and Senén. Church of Saint Peter, Terrassa (Spain). In the backgrounds of Gothic altarpieces realistic urban landscapes appear for the first time. They are treated using very schematic shading and simplified lines.

Shade on Buildings

Drawing architecture accurately requires the understanding of the way geometric forms appear in perspective. With a good working knowledge of perspective, an urban landscape can be visualized and blocked in by using simple geometrical forms such as cubes and cylinders.

Buildings are nothing more than geometric forms on a large scale. The interplay of light and shade falling upon them therefore acts more or less in the same way as it would upon all basic volumetric forms. However there is a difference: buildings are not smooth, and most of them have surfaces that are elaborate with details and elements belonging to their architecture and that therefore have to be represented. These architectural elements cast their own

The simplification of forms in this preliminary sketch of an urban landscape allows for a strong, clear depiction of light and shade. When buildings are crowded together, their shadows fall one upon another. (Work by Myriam Ferrón.)

Light and Shade in Landscapes
Shade in Urban Landscapes
Light and Shade on the Figure

41

Urban landscape with stone house. Because they are built of stone, these structures have particular texture and color. Notice how the shadow of one building is cast with sharp edges on the building opposite. (Work by Ricardo Bellido.)

The Intensity of Light

Buildings usually have four facades that are located in relation to the points of the compass, north, south, east, and west. There are times, however, when there are only two surfaces visible, as the other two are shared by other buildings. The effects of the light or the sun on a structure will vary dramatically. Dawn casts blue shadows. Early morning and evening lights can dazzle a cityscape with orange. An early afternoon sun may saturate color fairly evenly. The degree of illumination and shadow is critical in the coloration and overall impact of the urban landscape.

shadows onto the buildings they are part of, while the shadows of buildings that stand in proximity also fall on one another.

At this point we can establish a few basic rules. The shadows that fall on architecture are always sharply delineated with any variation of shape clearly marked. Also, because they are outdoors and because light changes very rapidly with the movement of the sun, the work of depicting urban architecture requires speedy resolution. Outdoor work can be general, as smaller details can be finished in the studio.

The Color of Illuminated Areas

The color of buildings depends on the material with which they are built. A building made of brick is not the same color as one made of glass. This particularity of color is known as local color. This local color is then toned and graded to reproduce the amount of light that strikes it. Colors appear less saturated the greater the intensity of light that illuminates them. In contrast, when

the light is moderate, colors appear to be more intense. The local color of a material remains the same, but appears to vary depending on the amount of light that falls on it.

Styles of architecture and building materials vary greatly depending on their locale.

One useful trick in painting urban landscapes is to combine tones of the same color. In this way you can use varying intensities of tone to differentiate areas of light and shade. For example, if one wall is illuminated by the sun at mid-day,

the change of its local color towards ochre will suggest the degree of warmth of the sunlight, whereas the adjacent wall, as it appears in the shade, can be depicted with a more bluish tone. This combination will also help to establish the structure of the building and convey the illusion of three dimensions.

The volume of this building, which is a simple rectangular form, makes it possible to study the influence of the sunlight falling on its facades. While the main facade is well-lit, the one beside it receives less light, with one side cast in an intense shadow. (Work by Miquel Ferrón.)

MORE ON THIS SUBJECT

• Light and Shade in Painting p. 28

LIGHT AND SHADE ON THE FIGURE

The human figure has been the central subject of art for centuries. The great masters demonstrated their different solutions to the problem of light and shade by means of the figure, finding formulae that are still in use today. The human form continues to be a particularly important theme for the development of tonal values, modeling of form, and the representation of dramatic subject matter — all the elements that go into the practice of drawing and painting.

Shade in Anatomy

When depicting the human form as a theme, you must bear in mind that it is important to learn to represent the physical features that make the model an individual. For this reason it is helpful to have a working understanding of anatomy in order to do justice to a subject matter that is as complex and fascinating as is the figure.

The human figure is made of complex forms that relate to each other spatially, three dimensionally. The architecture of the figure is described and emphasized by the use of light and shade. The relationships of such dark and light tones to each other is one of the principal ways the figure can be convincingly represented. When you have decided on a pose, a good choice of lighting will help to articulate the subject matter. In this way you will be able to achieve a satisfactory degree of realism in the work. One example shown is a portrait of a child. In this portrait the forms are treated with gentle transitions.

In contrast, if you want to produce a portrait of someone with a strongly developed character, you would choose a more dramatic lighting that would serve to more sharply depict the features.

The Relationship Between Background and Figure

When rendering a study of the human form it is important to be sure that the figure does not end up silhouetted against the background. Both figure and background should be integrated, so that the model does not look like a lifeless doll, and the background does not end up too hard and fail to capture the model's character. This relationship of the figure to its environment is one of the most important relationships in painting and drawing. The connection between the background and the figure perspective-wise should be established in order that the representation is as convincing as possible. The figure has to be the center of attention, but the background must be constructed in such a way as to hold and support the figure.

Highlights in the Skin

The skin is a surface that reflects the light, so the tonal

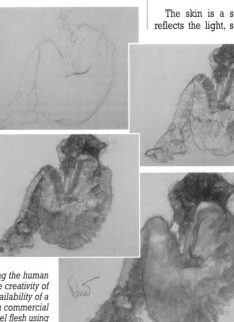

The tones used for representing the human figure depend greatly on the creativity of each painter. Despite the availability of a wide range of fleshtones in commercial pastels, it is also possible to model flesh using variations of hues both warm and cool. Yellow tones always convey light, while violets convey darkness. (Exercise painted by Joan Raset.)

Children's faces are usually depicted using very gentle contrasts, in order to accentuate the softness of the generally harmonious features, (Work by Ramón Noé.)

variations that it creates must be depicted. When light strikes part of the body directly, it is reflected especially strongly at certain points so that they shine. To express these highlights using any medium, remember the first rule of simultaneous contrasts: "A white becomes whiter the darker the tone that surrounds it."

Even small highlights adapt themselves to the form on which they are located, following the curve of a hip or the shape of a leg.

The Model in Light and Shade

When using the human figure for a drawing or painting, first place the model in a particular light, natural or artificial, direct or indirect, frontal or lateral. Once you have decided on the pose and the illumination, determine the composition and the scheme of light and shade. The model can be depicted in strong contrast to the background, or with certain forms blending into it.

MORE ON THIS SUBJECT

• Practicing with Pastels p. 72

Soft Shade

Soft shade lies in the intermediate areas between maximum light and maximum shade. Whenever a gentle gradation of tone is used, it produces an atmospheric effect.

If you work with a monochromatic composition, tonal gradations of the principal color will be used. This can be done by soft shading and blending or by superimposing strokes, depending on the type of technique being used to create the work. If you use color to express light and shade, the figure can be created by establishing chromatic contrasts in a single range or in various ranges.

Modeling the Light on the Body

Depicting a figure using chiaroscuro means using light and shade in strongly contrasting values to create a dramatic sense of lighting.

The human figure is a succession of volumes always seen in relationship to each other, so that no element should ever be treated separately. The figure can be represented successfully by the careful use of observed light and shadow as it describes form. Shaping the figure is simply constructing it by means of the successive contrasts of light and shade. Both the lightest and darkest points must be represented, as these points of light and shade in part create the impact of the composition. Once these extremes are established, the intermediate points of light and shade can be worked with more freedom.

Caravaggio, David with the head of Goliath. The Prado, Madrid. In this dark, dramatic work the human figure is seen more as an effect of line and contrast than as a result of color relationships. The contrast of light and shadow is so strong that the figure seems to emerge from the darkness. Such relationships of dark and light representing dramatic themes are typically Caravaggio.

RELATIONSHIP BETWEEN BACKGROUND AND FIGURE

It can be very challenging to relate the figure and its surroundings, representing the space around the figure to support and extend its meaning. The background and environment for the figure should work harmoniously. One way to achieve this is through effective treatment of light and shade.

The Importance of Background

When you create a composition, the background must be in harmony with the main subject, so it is always advisable to consider the composition as a whole before adding color.

In drawing, unlike in painting, the separation between background and figure is always easier, as it is possible to play with the tonal values of the outline to show the border between one plane and the other.

Often, resolution of the background gives atmosphere. This can be done by starting with a well-defined sketch and then resolving the picture in a monochromatic scheme. In drawing it is enough to suggest variations in value and contrast between background and figure using the same color range.

To strengthen the effects of light and shade on a figure, it is possible to use the technique of surrounding the figure in a light, nuanced background that will immediately darken the figure as if it were silhouetted against the light. (Work by Mary Franquet.)

How to Highlight the Main Elements

Although one should always aim to integrate background and figure, it is also necessary

Gustav Klimt, Portrait of Freiderike Maria Beer. *Private collection. This is an example of the ornamental treatment of both background and figure. Klimt handles the representation of this figure as a portrait. The face and character of the model is highlighted, supported and extended by the treatment of the environment.*

to strongly differentiate between the two so that the composition is understandable to the viewer at first glance, otherwise the composition will lose its power. This means that the background should never be more important than the figure, and should never stand out from it. To achieve this objective, the forms in the foreground, in other words the figures, must be more clearly delineated than any of the other elements in the background.

In addition, bear in mind that when highlighting figures against the background, the background must always be located as a more distant plane, and so it is always darker. Speaking generally (and remember that lighting and composition can work in many ways,) everything that is well-lit will tend to appear closer to the viewer, and everything that is less illuminated will read as a secondary plane, further away and less well defined.

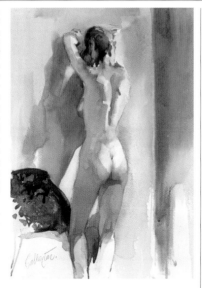

Figure seen from the back, painted in watercolor. The background offsets the form of the figure in a way that is completely atmospheric. The figure appears as the center of the composition, and creates a more delicate appearance than if it had been placed against a strongly defined background. (Work by Vincenç Ballestar.)

Color, Background, and Figure

When creating a work there are two basic ways of painting, one placing the emphasis on tonal value, the other on color. Tonal value is made by the study of light and shade. In this method, a form is represented within the same color range, which varies in tone depending on the amount of light that the area receives. The shade is understood as a darkening of local color at its most saturated.

If, in contrast, your aim is to represent your subject through the juxtaposition of colors, rather than using light and shade, try to represent each tone of light with a different color instead. This way of painting has been widely practiced since its advent by the Impressionist painters.

Always bear in mind that there should be harmony between the background and the figure, and that this can be achieved using both methods.

The background should never be smooth and light. It is better to use medium colors, and in some cases darker ones, to better establish the light areas in the foreground. It is always better to use washes rather than leaving the support unpainted if you do not want to draw anything in the background. In this way the composition will become more dynamic.

Using Complementary Color Between Background and Figure

When working in color juxtaposition, rather than depending on values, take care when choosing the colors for your palette. One effective approach is the use of complementary colors for the strong visual effect produced when they are combined, precisely because each is intensified by the other. It is not necessary to use pure colors. You can leave one color pure and mix the other one to reduce its tone. This way of working can be very effective visually, as pure color, complemented by its opposite, in broken, neutral mixtures, can be quite beautiful.

MORE ON THIS SUBJECT
· Light and Shade on the Figure p. 42

Using a painting by Badia Camps, it is possible to make this study of background and figure by means of the use of complementary colors. In the first painting, with a yellow background, you can see the color of the skin tending toward its complement, blue. If the figure is placed against a magenta background, the body of the model acquires a greenish nuance. If blue is used as the predominant background, the tone of the skin will tend toward red.

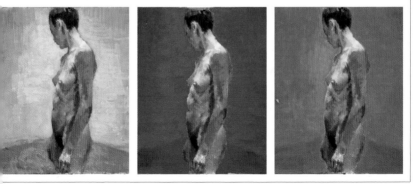

SHADE AND LIGHT WITHOUT MODELING

During the first decade of the twentieth century, a new trend in painting called Cubism introduced itself into the world of art. Its greatest exponent and practitioner was Pablo Picasso. The Cubists expressed their vision through planes of color, introducing the new concept of depicting forms two-dimensionally with the representation of several spatial points of view. In other words, artist and viewer appear to be seeing the figure or subject from several points of view at once.

Explaining Volume Through Planes of Color

It seems impossible to conceive of a work in which volume is not expressed through the chromatic interplay of light. However, the Cubists opted for a type of resolution that entirely changed the perception of what until then had been considered valid. Although in many Cubist works one can find color gradations, one of the great innovations was their use of blocks of flat color.

To express volume by means of flat colors, it is necessary to analyze composition. The artist must structure forms by means of planes that define one another. In other words, the painter has to delineate contrasts of light and shade using structures that express volume.

The relationship between light and shade is constructed by using planes of color. The darkest colors represent the areas where the shade is most pronounced, while the lighter

Roger de La Fresnaye, Bathers, Sara Lee collection. The construction of volumes by means of planes of color is one of the main characteristics of Cubist painting. The planes tend to be hard and geometrical, only broken by occasional curves.

colors depict the areas with more light. It is characteristic of Cubism that composition is treated using geometrical forms.

When working with chromatic planes, you must be careful to avoid two types of error that are very common in this style of work. First, the composition must not be weighed down with too many contrasts, as the spatial concept will be confused. Second, neither must the opposite occur, that is, by using too many subtle contrasts, the work could lose impact and power, and appear unfinished or unresolved.

Gouache and Acrylic in This Process

Both gouache and acrylic are water based and use water as their solvent, even so both media will cover the support opaquely, which allows the artist to create works using flat areas of color.

In the development of a work using planes, one should aim to achieve the most contrast between adjoining

In this study in acrylic by Jordi Homar, light and shade are painted using large blocks of color, located on different planes. Once the general tones have been established, layers of paint are applied in order to create the volume of each plane, establishing the chromatic scheme of the painting.

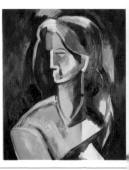

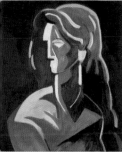

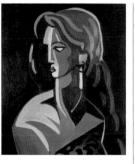

MORE ON THIS SUBJECT
- Absence of Grays in Ink Drawings p. 60

When the color of the larger planes has been blocked in, the artist moves on to the details. This painting has a linear treatment. The final result is a flat painting that is full of internal rhythm through the counterpoint of juxtaposed chromatic planes.

areas in order to express the volume of a body as effectively as possible.

Developing Flat Shade

Although working with flat color does not require explicit gradations, in order to effectively express the tonal value of different areas of light and shade, it is necessary to maintain chromatic consistency throughout the work. The painting techniques normally used in this type of work are usually opaque, as in this way it is possible to make corrections using light colors on top of dark ones without difficulty, provided that the first layer has dried properly.

You can begin applying color with a general harmonious tone, and then add nuance to the darker colors.

Color and Line

When the expression of a volume does not depend on tonal gradations of dark and light, line must play a greater part than usual in depicting the intricacies of shape, taking on greater weight and energy than in other styles of pictorial representation. A powerful suggestion of volume is found in the rhythms of lines, to the extent that it is possible to remove all shading, provided that the movement of the lines defines the relief of the subject.

While line can be a great substitute for conventional modeling, flat color can not give rise to the sensation of volume until it contrasts with other tones. Using contrast, the artist can express relief (although not the roundness of form). Planes can be distanced from one another and it is possible to visually separate the foreground from the rest of the composition. A painter such as van Gogh uses the juxtaposition of colors to represent his subjects. His strong, rich colors serve to convey form and volume, and the distances within the composition. The example of van Gogh has been much followed by many painters of the twentieth century who often avoid the use of dark tones. Van Gogh, and other painters of his time, set new boundaries for powerful visual expression using saturated color.

Ogatu Khōrin, Irises. Nezu Museum, Tokyo.

Vincent van Gogh, Irises. Private collection.

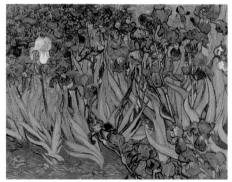

The individual vision of cultures and artists is what makes painting continue to change. Two identical objects depicted in different ways characteristically represent two cultures and two continuums of painting development.

DRAWING MEDIA

Figurative art is based on the representation of the reality that surrounds the artist in any given culture. The ability to understand the effects of light that surround an object is important in order to be able to represent volumes in a coherent way. This understanding is fundamental for expressing a three-dimensional form on a flat surface, canvas or paper.

Drawing Media and Tonal Values with Gray

Putting aside techniques that include color for a moment, there are many ways of producing a tonal gradation of grays that vary with different mediums. One commonly used drawing medium, especially at first, is charcoal. All charcoals are literally burnt or blackened wood. Black chalks are made of concentrated, pressed dust, which comes away when it is rubbed on the paper. Charcoal, unless it is compressed, has no agglutinate or binding agent so that less of its material tends to stick to the paper than with chalks, which contain sticky substances to make them adhere more easily. Both soft drawing

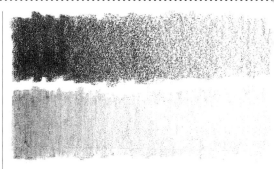

The variety in hardness within a single medium, such as graphite, can produce very different values of gray. The most intense blacks are achieved using very soft graphite, while harder graphite never produces complete black, although it is ideal for soft treatments and for producing intermediate tones.

media are used in similar ways, based on the progressive darkening from the lighter grays of the composition to the darker ones. Ink techniques vary according to the method of application, whether it is pen, reed, or brush. Washes are based on a variation of tone made on the paper, reserving the whites from the start, as the medium does not allow corrections to be made once it has been applied. Pen or reed techniques are based on a linear treatment, in a similar way to a graphite stick or pencil. The fact that pens and reeds have fine nibs means that creating tonal values is a slow process, of building networks of fine lines to fill areas with

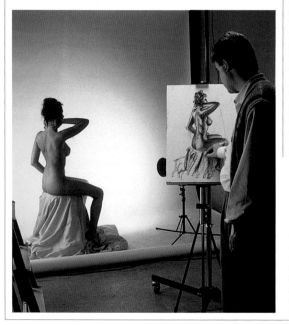

The artist should think about the illumination of the model beforehand, so as to achieve the most effective degree of contrast. Having a dimmer switch or several spotlights can help, so that you can try various alternatives before choosing the desired effect.

hading. Such shading or values of gray can be made using cross-hatching of parallel lines or a variation of strokes, keeping the marks sparse for the lightest areas. This repetition of marks will increase in the areas with the most intense values, where a myriad of strokes superimposed one on another will create the dark tones required to depict the volume of the model.

Shading with Different Media

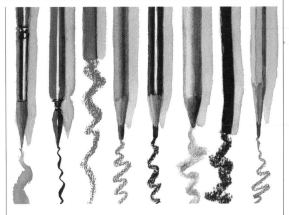

Each medium offers different possibilities for blending and expressing tonal values, depending on its individual characteristics, hardness, softness, stick, pencil, pen, or brush.

Apart from the light itself that surrounds a scene, the contrast and volume of a work depend on the medium and the technique used. Whatever the particulars may be, it is necessary to represent the tonal scale from dark tones to light, as well as a full range of halftones. Each medium has its own rules for finding these variations and expressing them on paper. Soft media like charcoal or chalk and pastels need to be blended, rubbing the pigment on the paper until it adheres to it and is fixed. When working with color, contrasts can be made using different tones, blending them together until the sensation of tonal gradation is achieved. In the case of a monochromatic work, the medium is handled much the way black charcoal or chalk is, blending it to indicate tones and values, reserving the white areas, and going over the darks to deepen tones.

Hard media such as graphite, colored pencils, or pen and ink are used in a completely different way. Since these are linear type media, the tonal values of the drawing are not based on blending but on cross-hatching the pencil or pen strokes. When working with color it is always possible to use different tones for darker areas. When working with black and white it is necessary to go over the strokes, making sure the white parts are left uncolored and making denser networks of cross-hatches where the grays are darker.

Values done with water-based media always depend on the amount of water that is mixed with the color. Whites are still reserved, while for grays, a lesser amount of water is used. Black is produced by using just enough water to allow the paint or ink to cover the support.

The Hardness of the Medium and Grays in Light Areas

In any of the techniques used for drawing, a distinction must be made between techniques in which the color can be altered later and those that cannot be changed. The latter case includes washes and any technique that uses ink. With these mediums it is necessary to reserve the white areas right from the start. With washes, lighter grays are achieved by using a greater amount of water, adding ink to make it darker. For techniques using reeds or pens, even felt-tipped pens, the white is represented by the white of the paper, and the lightest grays are represented with a few, widely separated strokes. Colored pencils, graphite, and soft media like charcoal or pastels, allow corrections and the opening up of light areas using an eraser. The eraser is not only used for correcting mistakes, it can also be used with soft media, such as charcoal, to reveal intense whites that show up against grays that have already been blended. With chalks and pastels, the tonal values can be worked by adding and blending in successive layers and stages.

MORE ON THIS SUBJECT

• Light and Shade in Sketches p. 26
• Creating Shaded Areas with Pen and Ink p. 58

TECHNIQUE AND PRACTICE

USING SHADE IN A DRAWING

When we talk about design we are necessarily dealing with perspective and composition.
But it is important to remember that a major part of a design is based on tonal variation
as well. Variations in light and shade are powerful composition tools and most
often play the dominant role in the overall impact of the piece.

From Blocking In to Separating Tones

Blocking in is transferring forms from nature onto the canvas or paper using simple geometric figures. These forms are then situated within the composition, so elements are linked together into a whole.

Normally, blocking in is done using line drawing, the volumes being simplified until a more or less accurate outline of the forms is drawn. But during this stage tonal differences caused by the interplay of light and shade must also be indicated. Once this exercise is complete, you can establish the first tonal values.

The study of shade from a drawing should be understood as a form of modeling. Once you have properly defined the outlines of the model, you can make the tonal valuations, starting with the darkest and the lightest tones.

Studying Tones on the Model and on the Drawing

Whenever you create a sketch, first observe and study the model thoroughly so that you can then transfer it to paper. In a monochromatic sketch, values range from the color of the paper used to deep gray, if you are using graphite, or black if you are using charcoal. Organizing a subject into a wide, clear range of tones is important for the strength of the work. All the colors that surround us can be translated

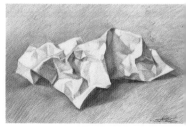

When working with graphite, the effect of chiaroscuro, strong darks and lights, is achieved by repeatedly going over the area. It can be a good exercise to use a sheet of crumpled paper as a subject. In the example the crumpled paper is carefully observed, drawn as a complex configuration of graded values. Dark tones are achieved by increasing the pressure on the pencil. (Exercise by Miquel Ferrón.)

into monochromatic tones.

The transition from color to monochromatic interpretation occurs through careful study of the interplay of light and shade. Practice looking at the model through half-closed eyes, filtering the scene through your lashes. The definition of the outlines is blurred and the tonal contrasts can be seen more clearly. By viewing your subject this way you can make a tonal interpretation of light and shade, rather than of color. This will, in effect, give you the pattern of darks and lights for the monochromatic drawing, eliminating natural colors that can distract attention from the values of light and shade.

Maximum Dark Areas and Individual Light Areas

The maximum dark area falls opposite the light source. It is always better to set this area at the start of the work as an intense gray. This tone can gradually be increased in value toward black as you work on the rest of the drawing, rendering transition tones closer to light gray where dark joins light. Individual light areas can be made in three ways. The first uses simultaneous contrast, increasing the dark around it so it appears lighter. The second uses an eraser to remove charcoal and the third accentuates the light area with white chalk.

Drawing Media
Using Shade in a Drawing
Opening Up Light Areas in a Composition
51

Resources for Drawing: The Eraser

An eraser is not just used for correcting errors on a drawing, but it also allows you to highlight parts of it using different effects.

There are different types of eraser. Commonly used are the standard rubber eraser and, plastic or vinyl erasers, all of which are useful with graphite sticks. These erasers should not be used with charcoal, chalk, or sanguine however, as they will have little effect.

Whenever working with chalky pencils or charcoal it is better to use kneadable putty erasers that can be shaped with the fingers. When a kneadable eraser is covered in charcoal, it can still be used, as kneading it will in effect clean it again, one of the reasons it is such a good tool.

Erasers are only used when necessary, since using them too much destroys the fiber in the paper. Large pieces of the kneadable eraser can be used to erase a large area, but it can also be cut up and used in small pieces, which will also makes it easier to handle.

In contrast, if you want to use an eraser as a drawing medium, you can do so to open up white areas, in order to create areas of light tone and to emphasize outlines. If you want to lighten a tone, press the eraser firmly over that area without rubbing. If you want to make a highlight, do the same thing, but tapping the area several time with the kneaded eraser. You can also easily shape the eraser to the highlight you are trying to create. To make lines, draw with the eraser passing over the surface of the paper with greater pressure.

MORE ON THIS SUBJECT

- The Study of Light on Simple Elements p. 24
- Drawing Media p. 48

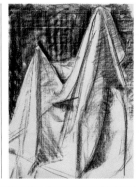

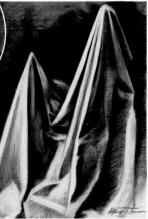

The technique of charcoal drawing demands that the artist works evenly over the whole composition in general. Only in this way can you balance the areas of light and shade. (Exercise by Myriam Ferrón.)

Blending Dark Areas

To blend different tones, rub the surface gently, so that the charcoal is distributed uniformly over the parts you want to blend. Areas that are not blended will remain fresh, textured by the grain in the paper, while those that are blended will seem smoother. In light or white areas the grain of the paper can be seen, while in the dark areas the effect is an even, continuous surface, the pigment covering and filling in the textured surface.

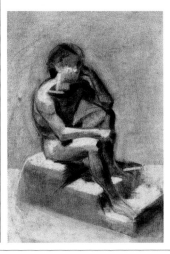

When drawing with charcoal, as in this picture by Esther Serra, one element effectively used for opening up the lightest areas is the eraser. In this study there is a rich gradation of tonal values ranging from very dark to very light. This creates the effect of a sharp light source and makes for a strong drawing.

TECHNIQUE AND PRACTICE

OPENING UP LIGHT AREAS IN A COMPOSITION

Creating effects that make the bright points stand out and allow the interplay of light and shade to produce a specific effect in a drawing open up light areas in that drawing. The ways to achieve this effect are many and varied, and involve the paper, the drawing medium, the use of fingers, erasers or special effects, and the gradation of grays.

The Paper

The type of paper that is best used for a drawing depends on the type of technique being employed. There are rice papers, plasticized paper, and linen papers. The paper can be rough or glossy, thick, medium or fine grained, colored or white.

When drawing with charcoal, the paper known as Ingres has long been used. This is a laid paper, which means that the fibers lie perpendicularly. It has a medium grain and an eraser can be used on it with ease. This paper can also be used

with chalks, Conté crayon, or colored pastels, although it is more common to the use of these techniques to employ a thicker-grained paper, such as Canson, because it has two useable sides, one thick-grained and the other medium-grained.

Fine-grained papers and glossy papers are ideal for drawing with a lead or carbon pencil and pen and ink, respectively.

The Medium to Use

When you choose charcoal, chalks, sanguine, or sticks of

MORE ON THIS SUBJECT
· Highlights and Shine Using White p. 54

colored pastels, remember that you are choosing media that demand long fluid strokes. For this reason the size of paper, especially with charcoal, will be large. It is also useful to bear in mind that charcoal is best used when suited to the subject matter, for instance when making studies of light, shade, and modeling. As charcoal is a relatively easy medium to use, it is very suitable for beginners. Fine charcoal can be rubbed off by going over it with a cloth. Compressed charcoal and Conté crayon will leave a residue that will not come off, even with an eraser, so those materials need more sensitive handling.

But, despite being one of the best mediums for drawing, charcoal is very unstable, so it is necessary to fix it once you have finished the piece. Fixative can be one of two types: liquid fixative, which is sprayed with an atomizer, and aerosol fixative. Hair spray and other lacquers can be used as well, although it is always better to use commercial fixatives that are made specifically for this task.

Lightening a Tone with Your Fingers

Again, when using charcoal, unless the stick is pressed down firmly, this medium rubs off easily, yet it is this very quality that allows various effects to be created in a drawing.

The result of a drawing depends in part on the thickness and the texture of the paper. Greater thickness ensures a greater resistance to erasing or shading with your fingers, and presents a surface that won't crease. The roughness or texture of a paper will affect the look of line and shading. With smooth paper, you can make fine, precise lines. Rough papers are ideal for creating atmosphere.

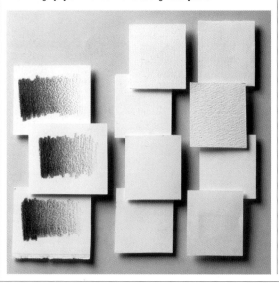

Using Shade in a Drawing
Opening Up Light Areas in a Composition
Highlights and Shine Using White

53

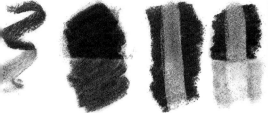

With charcoal, light areas can be opened by using fingers to lighten areas of gray tones. Areas can be further lightened by going over them again with an eraser. Uniform gray areas are easily created by coloring the support with charcoal, then going over the area with a cotton cloth. The more a charcoal-covered area is blended or worked with a finger, the darker it will appear. (Excersice by Jordi Segú.)

To illustrate this idea, try covering a sheet of paper uniformly using a stick of charcoal. This will create a black tone of greater or lesser intensity. If you draw a clean finger across the charcoal surface, some dust will be removed, creating a line in the charcoal the thickness of your finger that is lighter than the rest of the paper. To make it even lighter, repeat the process. Always have a cotton cloth or paper toweling nearby, to clean your hands and to further work the surface of your drawing.

Lightening a Tone with an Eraser and Creating Special Effects

A kneadable eraser is a basic element in charcoal drawing. When charcoal is used with an eraser, much better effects can be achieved than by just charcoal alone.

This great pair can be used in two ways. The first consists of using them in localized, specific areas of the composition to highlight extreme bright points or to make blends in intermediate shaded areas. The

reflected points of light in a glass bottle or a piece of metal are extreme highlights that can be created by shaping the eraser into a cone and pressing it firmly onto the paper, but without rubbing, wherever the effect is required.

Another way to use an eraser for drawing with charcoal is to work from dark to light, using the eraser to lighten and tone, which can create a very atmospheric effect. Start by toning in the background completely. Next open up light areas using the eraser, starting with dark grays, until you reach the color of the paper in the areas of maximum light.

Smudging Gray

To achieve different tones of gray using charcoal, it is a good idea to use a cloth or a paper stump. The cloth is used to color large areas a gray tone by dragging it over the paper. The paper stump is used to color small, detailed areas.

When you want to create white areas, an eraser is a good tool; to lighten large areas, you will have to keep the surface clean.

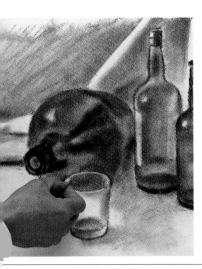

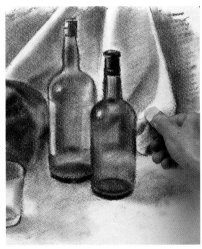

For smaller areas, it is a good idea to use a cutting tool to cut the eraser into straight-edged pieces. Then you will be able to erase linear shapes accurately, as if you were drawing with a white chalk. (Exercise by Jordi Segú.)

TECHNIQUE AND PRACTICE

HIGHLIGHTS AND SHINE USING WHITE

Highlights created with white are characteristic of drawings done in charcoal or Conté crayon. These highlights complement shading and can only be used if the support you are working on is tinted with color. Some commonly used colors for such highlighted drawings are sienna, ochre, or gray. The white applied is usually chalk or pastel. Highlights are the perfect complement to modeling a form by means of shading and tonal gradations.

Colored Paper

It is helpful to remember that in the execution of a painting all its elements are important: the subject matter, the support, the technique, and so forth. If the support is paper, there is a wide range of types to chose from. When choosing paper, its particular quality must be considered, whether it is rough or glossy, laid or not, as must its color. Both Ingres paper and Canson paper come in a wide range of colors that will have an impact on the work.

The choice of one color or another depends on the artist's preference, and the type of technique that is going to be used. For working with charcoal, graphite pencil, chalks, or Conté crayon, it is better to use neutral colors such as white, bone, beige, light or medium gray. Other colors can be used but they may distract attention from the subject matter.

If you have decided to work with pastel colors, any color paper will do. The choice will

Jean-Antoine Watteau, Figure for Spring. *In this work by the French painter one can see the use of three materials in combination: charcoal, conté crayon, and white chalk, used on a support of cream-colored paper. The white chalk is used for bright highlights.*

always depend on the tastes and vision of the artist. It may also be helpful to take into consideration the coloration of the subject matter and choose a color that will serve as a strong foundation.

The Importance of White Chalk

White chalk is one of the most commonly used drawing materials. Its origins go back to the Cretaceous period (*creta* is Latin for chalk). Chalk is a mineral of organic origin that is white or gray in color and has a soft consistency.

Chalk is then mixed with agglutinates, which act as binder, then shaped into sticks or pencils for use in drawing.

Chalk sticks are also manufactured with colored pigments, but white chalk, that is chalk in its primary state, is traditionally used in drawings for expressing shine and light effects. This use came into wide practice in the fifteenth century, along with the advent of handmade papers. In the eighteenth century its use was as extensive as charcoal and Conté crayon.

The use of white chalk should never be excessive, as its effectiveness rests on its spare application of highlights, perhaps, of a few key strokes. Using chalk for all the bright points would diminish its strong effect.

Canson papers are available in various colors that work well for drawing with charcoal, Conté crayon, pastel, and white chalk.

Opening Up Light Areas in a Composition **55**
Highlights and Shine Using White
Light and Shade in Sketches

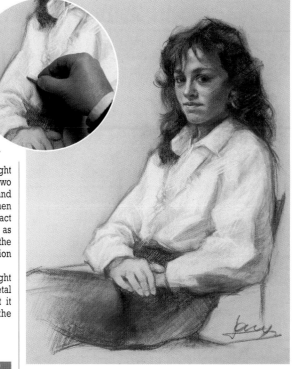

The use of white chalk is beautifully set off on these richly toned and colored papers.

Soft and Hard Light Points

In any composition of light and shade you can find two types of light points, soft and hard. Soft shine occurs when the light comes into contact with a rough surface, such as the skin, in such a way that the shine that occurs is a gradation from light to shade.

Harsh shine is when the light bounces off a glass or metal surface in such a way that it stands out sharply in the composition.

MORE ON THIS SUBJECT
· Opening Up Light Areas in a Composition p. 52

In the illuminated parts of the face a white chalk is used sparingly. For the clothes, the areas showing the folds are left uncolored allowing the color of the paper to come forward. (Drawing by Miquel Ferrón.)

How to Integrate the Color of the Paper into the Composition

Whenever a drawing is made, in addition to the technique being used, consider the color of the subject, particularly in relation to paper color. Just as background and figure must be integrated, the color of the paper must be well integrated with the subject matter and used to build the strength of the drawing. One effective way to make use of the paper's color is to reserve it for highlight areas when using charcoal, and as a background to the composition when using colored pastels.

When one color dominates in a particular subject, for instance the red of the apples and floor in the pastel shown, a paper of the same color may be used. Integrating the other colors of the theme with the background can unify a composition. (Exercise by Ana Roca-Sastre.)

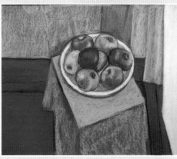

LIGHT AND SHADE IN SKETCHES

The importance of sketches in the process of creating a work of art can be compared to research in scientific processes. Sketches are a rapid means of finding the form and composition of a theme, and are an excellent exercise for achieving fluency in drawing. Sketching is the practice of making rapid visual notes of the scene you wish to handle. A sketch is particularly important for the development of a realist composition or a figurative character.

Synthesizing Forms

A good sketch creates a brief suggestion of the interplay of lights and darks. It is also important that a sketch establish forms of central interest to the composition, while minimizing details that could distract the attention from the painting's focus. Although it may be possible to include every detail of a theme, an excess of detail may have the effect of weakening the painting's overall impact.

For this task the careful observation of your subject is vital to create a convincing two-dimensional representation. During the sketch stage the basic forms that best describe the model should be established as well as the important lines. Through the sketch process the artist will establish the correct proportions of the model and the figure to environment relationship. Rhythms and movement are also

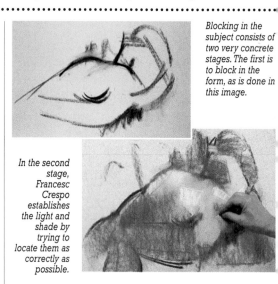

Blocking in the subject consists of two very concrete stages. The first is to block in the form, as is done in this image.

In the second stage, Francesc Crespo establishes the light and shade by trying to locate them as correctly as possible.

blocked in at this stage.

In a sketch it is also possible to include studies of light and shade. In this case, it will be a tonal analysis of the subject matter.

Blocking In and Shading

Blocking in is a compositional technique that experienced artists practice routinely. It is an important practice for use every time you draw, both in sketches and in blocking in a

Correcting Light Values

Once the sketch is done, you can tune it further by correcting light values, which consists of establishing the strongest, most important light and shade values.

composition. Blocking in is done by means of indicating large general three-dimensional forms. Each form that is part of the subject matter is sketched with clear indication of direction, or three-dimensional orientation so that forms are situated firmly on the work surface. While sketching the artist also strives to create a ...monious composition. Once the sketch of lines and forms has been established, the next step is to make a tonal sketch.

Once the subject has been blocked in, the question of light can be addressed. The tonal

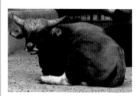

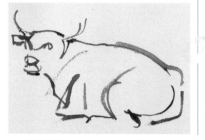

An excellent example of a line sketch. Using just a few lines, both the form and the attitude of the animal are perfectly expressed. Sketch by Vicenç Ballestar.

Highlights and Shine Using White
Light and Shade in Sketches
Creating Shaded Areas with Pen and Ink
57

A good blocking in of the subject must be made initially based on the forms of the objects in the scene, as well as their spatial location. In the second stage, you can begin to establish the main highlights and areas of shade, without losing the linear blocking. Later the medium tones are established by blending. Then make any necessary corrections to light and shade. For this an eraser can be used. (Exercise by Jordi Segú.)

values of the sketch are established in the same way as was form and line, without focusing too much on the details but rather on the whole. Three or four values can be used, two for the maximum values of light and shade, and one or two for the intermediate tones. It is necessary to capture the darkest darks and the maximum highlights in order to establish the tonal interplay of the whole composition.

After you have developed the values of your composition in the sketch, proceed to color. The approach will differ based on the technique to be used.

MORE ON THIS SUBJECT
- Drawing Media p. 48
- The Study of Light on Simple Elements p. 24

From the Sketch to the Subsequent Work

The use of a sketch in the development of a work is a practice that has been followed since antiquity. Making an initial study will lead to better results. However, you should always take care that the finished work does not lose the freshness of the sketch.

1. Michelangelo, Study for the Libyan Sybil. *Metropolitan Museum of New York.*
2. Michelangelo, The Libyan Sybil. *Vatican City. A beautiful example of the way a sketch is done as a study for painting, by the Italian Renaissance master, Michelangelo.*

2

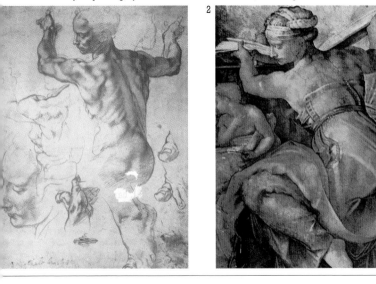

CREATING SHADED AREAS WITH PEN AND INK

Although most people think that ink is only used for writing, the world of art appropriated it thousands of years ago. Its origins are found in China around 2500 B.C. Despite the passage of the centuries, the technique of using ink has not changed, evidence of its excellence as a medium. Ink has been widely used by artists over the centuries because of the number of possibilities it offers and the many ways it can be applied.

Drawing with a Nib: The Thickness of the Line

Drawing with ink requires great care that is only equaled in watercolor painting. This is because once the ink is on the paper, it is almost impossible to remove, and retouching the surface tends to spoil the work. For this reason drawing with ink requires experience and practice so that the artist has a certain confidence when making marks on the paper.

Using ink can create a very dynamic drawing. Tones are always obtained by superimposing lines or strokes to make mediums and darks, or drawing lines sparsely at intervals for light areas.

When drawing with a nib keep in mind that there are different types of nibs available, each one made to produce a different result. The most common nibs are made of metal, and are inserted into and held by a shaft made of wood or plastic. Drawing nibs are a good tool because they produce fine lines that give the drawing a delicate appearance.

With square-pointed nibs you can make lines of different thickness, although you can also do this by changing the thickness of the nib.

The Correct Use of the Nib

To begin, it's important to learn to hold the pen correctly. When you write, only the wrist is moved, whereas for drawing the movement uses the whole arm, and so it is better not to lean on the paper or to hold fingers too close to the nib, as you will not be able to see the drawing.

There are different types of lines that, if you learn to combine them, will help to construct the composition, although at first it is better to practice them on their own. The first thing you should do is to get comfortable holding the pen, and try out some strokes.

First try drawing zigzag lines, wavy lines, and so on, which will change depending on the amount of pressure you apply. Then try making movements from top to bottom, and notice how the strokes can be given a curve before starting the next one. Continue by drawing circles and open curves. Finally, make vertical, horizontal, and diagonal lines parallel to one another. For this

MORE ON THIS SUBJECT
- Absence of Grays in Ink Drawings p. 60

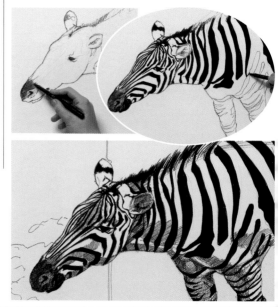

Ink can be applied using felt-tipped pens. These are available in a range of different thicknesses that can help the expression of any type of line. In order to create gray areas it is necessary to use cross-hatching with a fine tip. (Exercise by Myriam Ferrón.)

Light and Shade in Sketches
Creating Shaded Areas with Pen and Ink
Absence of Grays in Ink Drawings

59

it is best not to let your wrist move while you are drawing the line.

When working with a nib and ink, since you are not diluting the ink to make intermediate grays, you only have the black of the ink and the white of the paper at your disposal for creating light and shade. For this task you will have to use what is called the unifying effect of the eye; in other words, the closer these lines are together, the more the eye will see them as one block of color. If the lines are separate, on the other hand, they will be seen separately. If you make a series of parallel lines that grow increasingly thick, you can darken an entire area. Also, you can darken an area by cross-hatching, that is to say, crisscrossing straight lines of the same thickness.

Sumi-e, Japanese Wash

Japanese wash, or *sumi-e* painting, is a traditional form of Oriental painting, which reached the West in the nineteenth century by means of the trade routes and Western exposure to Oriental art. This technique is now widely practiced in the West.

Katsushika Hokusai, Birds in Flight. *Uffizi Gallery, Florence. This Japanese masterpiece manages to express a maximum of tones and forms with a minimum of elements.*

Ink can be applied with a reed pen in the same way as with a nib, although the result is rougher and less precise. Any ink technique can be combined with watercolors or other water-based paints. (Work by Miquel Ferrón.)

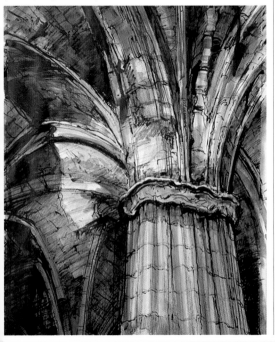

Drawing with a Reed Pen: Similarities with Dry Media

Using a reed pen for drawing with ink is a very ancient technique that came from China several thousand years ago, where bamboo pens were first carved. Bamboo reeds are very hard and come in various thicknesses. Several sizes can be combined in one piece of work to achieve a better result. This type of reed is never more than a rudimentary nib, but because it has such a coarse, blunt point, it can be drawn with on surfaces to make tonal gradations, making sure not to destroy the fiber in the paper. The nib must be held in a consistent position to control the thickness of the line.

Whenever drawing with a reed it is better to choose a rough paper that will absorb the ink. Drawing with ink and reed has some similarities in finish to graphite and sticks of Conté crayon, which, of course, are dry media.

ABSENCE OF GRAYS
IN INK DRAWINGS

Although there are inks available in different colors, the traditional type of ink (Chinese ink)
is always black. This creates the problem of how to create intermediate values and gray tones.
Most artists solve this problem by cross-hatching with very fine lines (if a nib is used),
by using a reed loaded with very little color, or by diluting the ink with water,
which gives a watery effect very similar to that of watercolors.

Drawing from Observation

Most important when composing a picture is the use of careful observation in order to represent the interplay of light and shade created by a specific light source. By drawing from observation the artist strives to reproduce form, light, and shade in a convincing way. Drawing line, form, and light from observation consists of rapidly blocking in the dominant elements of the composition. To best observe light and shade, once again, as mentioned earlier, half-close your eyes so that the outlines of

Francisco de Goya, Help. *The Prado, Madrid. Here one can appreciate the versatility of ink in expressing quickly, by means of a sketch, both the pose and the tonal values of the light and shade of the figures.*

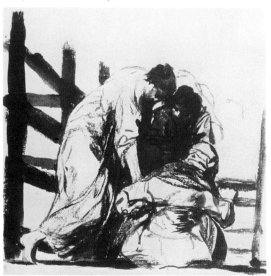

objects soften and disappear, giving way to general areas of darks and lights. This trick is particularly helpful when the value changes are subtle, but not as necessary when dealing with extreme contrasts.

Pure Light and Shade

The direct light of the midday sun in summer falling on a subject illuminates it in a way that creates pure light and shade. This effect can also be achieved when working indoors, using a very powerful light directed in the direction desired.

This type of illumination,

being very extreme, creates shade that is very hard-edged and clearly defined. On the subject, one can observe an area of light and another of shade, perfectly separated and with barely any tonal gradation.

In addition, the shadow of the subject will be cast quite darkly on adjacent vertical and horizontal planes, in such a way that you will be able to see its outline projected as an echo of the subject's form.

The Perfect Drawing

The perfect drawing does not exist, but it is something to which all artists aspire. In the case of a drawing using tonal variation, the most one can hope for is a balance between light and shade, and between background and figure. This can be achieved if from the start you choose illumination that will allow you to get the strongest effect from the subject matter.

Interpreting Using Brush and Ink

Ink can also be used by painting with a brush. A drawing made with brush and ink can help the artist become more fluent, as it is a technique that requires a lot of concentration and a great capacity for the visual synthesis of observed form.

As the technique for drawing with ink requires good materials in order to achieve

Creating Shaded Areas with Pen and Ink
Absence of Grays in Ink Drawings
Creating Tonal Values with Felt-tipped Pens

61

The blocks of shade create a strong pattern of contrasts, without intermediate tones or grays. The scene is depicted using black areas to represent dominant forms and deep shadows.

the best results, there are basically two types of brush that can be used. The first is a high quality paintbrush made of sable. A sable brush has a fine point that can be made thicker just by putting more pressure on it. The second is the Oriental brush. This was the kind of paintbrush that was used in China in antiquity and that has come down to us almost unchanged. It is a brush that is highly valued among artists because of its versatility in expression. It is used in a vertical position, and allows the artist to create everything from very fine lines and strokes to thicker marks and extensive blocks of color.

To make a drawing with brush and ink, you do not need much material. Just paper, a brush, ink, and a receptacle for water. Whenever using this technique it is necessary to clean your tools with water and a neutral soap, in order to keep them in perfect condition.

Drawing with brush and ink has one thing that makes it different from drawing with a nib: you can dilute the ink to obtain different shades of gray. In three or four receptacles pour different amounts of water, together with the same amount of ink. The best support for working with brush and ink is porous paper. Again, ink does not allow for corrections or working over areas, so the results tend to have the appearance of a sketch, fresh and spontaneous.

Another option for drawing with brush and ink is to use an almost-dry brush. By so doing, you get irregular strokes with entirely graded outlines, so you achieve a whole range of grays. Lighter tones come from big gaps between black areas, while darker areas are the reverse blocks of black with a few white areas. A dry brush achieves a more accentuated effect on grainy paper.

MORE ON THIS SUBJECT
- Creating Shaded Areas with Pen and Ink p. 58

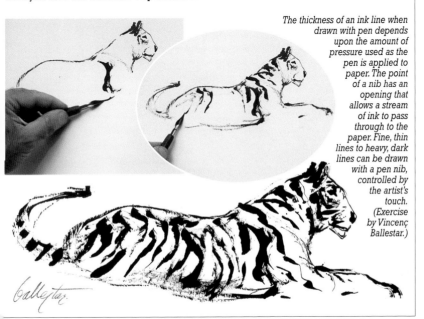

The thickness of an ink line when drawn with pen depends upon the amount of pressure used as the pen is applied to paper. The point of a nib has an opening that allows a stream of ink to pass through to the paper. Fine, thin lines to heavy, dark lines can be drawn with a pen nib, controlled by the artist's touch. (Exercise by Vincenç Ballestar.)

CREATING TONAL VALUES WITH FELT-TIPPED PENS

Felt-tipped pens are a medium not traditionally used in the field of fine art. Their use is restricted almost exclusively to technical drawing, preparatory sketches, or for creating labels and posters. In spite of this, there are some good quality brands of felt-tipped pen, available in a range of hues wide enough for creating paintings that are works of art, full of color and nuance.

Technical Resources

The artist must be constantly curious, and not just stick to traditional techniques, in the search for new ways of conveying aesthetic emotions. Water-based felt-tipped pens are excellent for creating tonal gradations. When water is applied, the color spreads to create a flat, graded effect. Without the application of water you can also make blends, but for this you must work while the color is still wet, applying one color onto another before it has dried, superimposing colors similar to watercolors so that the color bleeds.

Types of Line

Applying color with wide, parallel strokes is the most common technique for covering large surfaces. Changes in direction of the strokes help to differentiate between the planes. Superimposing the same color creates changes of intensity of the same tone, and when one color is applied over another it produces chromatic changes much like layers of watercolor.

Combing or sweeping effects occur when the strokes of the felt-tipped pen follow the form and rhythm of the surface texture, showing volume by means of the stroke, in the same way as with colored pencils.

Making a tonal gradation.

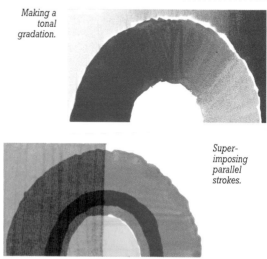

Superimposing parallel strokes.

Applying the color with thick strokes.

Combing or sweeping the color.

MORE ON THIS SUBJECT

- Creating Shaded Areas with Pen and Ink p. 58
- Mixed Techniques p. 94

Absence of Grays in Ink Drawings
Creating Tonal Values with Felt-tipped Pens
Light and Shade Using Colored Pencils

63

Combining Felt-tipped Pens with Water

There is a very wide range of techniques possible when working with felt-tipped pen as well as the potential to combine techniques. There are two types of felt-tipped pens, those using alcohol as a solvent and those that use water as a solvent. The latter are the most common to the field of art, as the variety of colors is wider and the tones are softer, so they can be superimposed on one another more effectively than with alcohol-based pens. Starting a work with an initial wash as the base creates a perfect foundation for devel-

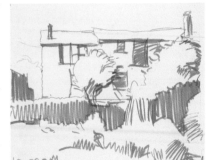

The painter Miquel Ferrón blocks in the scene with a grayish-lilac felt-tipped pen. This is a simple blocking in of shapes and forms, without details, which locates the basic elements.

opment with felt-tipped pens. Superimposing tonal values on the wash base will also create new tones. The pen strokes should range from broad, progressively to fine, using the

finest strokes to create the smallest details. In this way the work will progress from general coloring with a wash to the small details done with a fine felt-tipped pen.

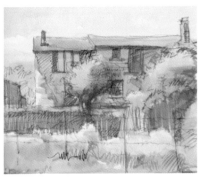

Developing the detail of the base by cross-hatching different colors.

Watercolor is applied over the layer of strokes covering the whiteness of the paper and constructing the atmosphere of color over which later strokes will be applied.

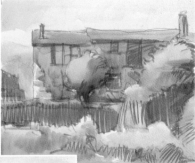

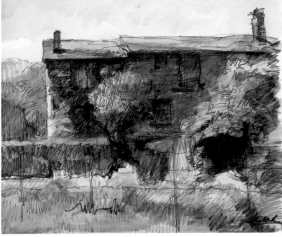

The final result: blocks of color combined with pen strokes produce an interesting effect.

LIGHT AND SHADE
USING COLORED PENCILS

Colored pencils are usually associated with childhood, but in fact they are an excellent resource for the artist for making sketches or color studies. They are also a wonderful medium for creating larger, more developed pieces as well.

Superimposing Tones Using Pencil Marks

Colored pencils are possibly the cheapest, cleanest medium that exists. They occupy the smallest space, and they do not deteriorate, although they should be protected, as their points are vulnerable to breakage as with any pencil. As with graphite pencils, they are available in different textures and hardnesses, as well as in a wide range colors that allows each artist to create their own palette as desired.

Colored pencils are very versatile, and offer a wide range of options for expression. Using this medium you can work in fine lines, either

Producing a work with colored pencils is slow, as the pencils do not cover opaquely, so the same area must be gone over several times to produce powerful contrasts. The tone of each colored pencil has its own shading capacity, but it is the combination of colors that will help to cover over the color of the paper support.

The stroke is fundamental to the technique of colored pencils, and not just for defining color but for expressing the volume of forms and the direction of line. (Work by Ramón de Jesús Rodriguez.)

intense or light, depending on the amount of pressure that is applied. These pencils can also cover an area with a flat tone of color so that you can create two effects: a line drawing or a drawing constructed of overlays of broad areas of color, much like glazing.

When working with colored pencils, color and line must be considered together. Color not only is used to cover a surface or area, but by means of networks of colored lines, will build volume and form as well. So areas of color are roughed in during the first stage of the work and built upon as the work progresses. This slow building of form, volume, and color is the strength of colored pencils.

There are different types of strokes which, with practice, will make your drawings more fluent. The first is the uniform stroke, or in other words a line that does not vary in thickness throughout its length. The second is a variable stroke.

Transparencies with Colored Pencils

Colored pencils are not absolutely transparent, but neither are they entirely opaque. Therefore they can be used to create mixtures by superimposing colored marks. In this way you can lighten or darken a given color.

With this you can make lines that change in thickness at specific points. You can also apply a short stroke, which joined to others will give a broken line. These are used to draw outlines, although they can also give volume. There are two techniques used to describe tonal changes, cross-hatching and point-work. Cross-hatching, as its name implies, consists of a series of parallel strokes that cross another series of strokes that are also parallel but slanted in a different direction. Point-work is done with the

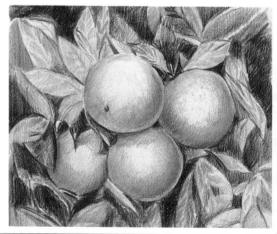

Creating Tonal Values with Felt-tipped Pens
Light and Shade Using Colored Pencils
Working with Crayons and Oil Pastels

65

Colored pencils are a wonderful medium with which to model forms and express details. A modernist cityscape such as this one by Miquel Ferrón is a good example of the tonal variety and richness of color typical of colored pencils. The rendering of this mosaic displays a complexity of color that requires the use of very sharp points, either using the pencils themselves, or by scraping the pigment with the edge of a knife on a surface covered evenly with color.

point of the pencil held at an angle. The points or dots vary in size and the spaces between them vary, so that a form will appear darker or lighter depending on the amount, size, and density of the points.

Shade and Color Theory

When working with colored pencils, it helps to understand color theory perhaps even more so than with other media. When complementary colors are placed together, they have a shimmering effect caused by their contrast, and each color strengthens the effect of the other. When orange is next to blue, the blue appears darker and bluer.

This also happens in warm and cool color ranges; their effect strengthens when seen together. Cool colors give a sense of depth and distance—ideal for strengthening shade.

MORE ON THIS SUBJECT

• Drawing Media p. 48

The Strengthening of Light Through the Use of Shade

Whenever you want to strengthen the appearance of a light area, darken the tones surrounding it. Then it will read as a highlight.

Colored pencils do not allow for a light color over a darker one. So when working with colored pencils, apply the lightest tones first, as a foundation, and then add the tonal values for the darker areas.

WORKING WITH CRAYONS AND OIL PASTELS

Wax crayons and oil pastels are two different materials, although they have very similar characteristics that allow the artist to work with both media in a similar way. The differences between the two media lie in their consistency and binding agents. Wax crayons are very hard and won't cover a surface as well as oil pastels. Oil pastels are softer and more malleable, and as the name indicates, similar to pastels. Like pastels, they can be used by applying a light color on top of a darker one, with excellent covering capacity.

Main Characteristics

To begin with, wax crayons are composed of pigment suspended in and bound together with wax, while oil pastels are made of pigment and oils. Both materials can be softened with the fingers so that the colors mix and create a gradation that is perfect for depicting light and shade. Blends can also be made by applying turpentine to the color. Both materials are grease-based and will dissolve in the same way as oil paints. It is possible to create effects of radical contrast by applying ink or washes onto strokes made with a stick of pigment. Its grease-based composition repels the water to create certain reserves that can be very interesting when depicting darks and lights or to express complementary colors. Both media are very difficult to erase, and so you should take care to make as few mistakes as possible. If this does occur, you can scrape down the surface with a palette knife and then erase what remains with a hard, plastic eraser. Scraping is commonly used with both media. When a dark color is applied onto a light one, you can scrape it with a knife or point so that the underlying color shows through.

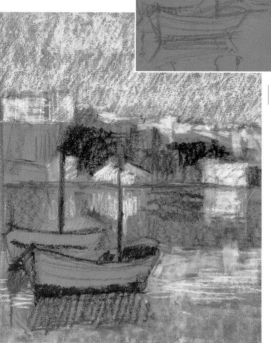

One effective way of creating tonal values in a work with wax crayons is to establish a strong contrast that will allow you to clearly see the intensity of the color. In this example you can see the excellent capacity of oil pastels to cover the support. Some very strong light areas can be seen, which can be established over dark colors. Because a colored paper is being used, it makes the whites stand out strongly right from the start. (Exercise by Joan Sabater.)

Tonal Values

Wax crayons and oil pastels are similar in their use to colored pencils, although they produce an effect that is much more painterly and less like a drawing than colored pencil tend to be. The process of painting with these media starts with the use of light colors and moves on to dark colors in the same way as when working with colored pencils. Contrasts get stronger as the work progresses. Since the pigment is in stick form it offers the possibility of covering large areas by using it on its side, while also being suitable for creating details and linear forms if it is held upright. The degree to which it may be used for detail is less than with colored pencils, though the pigment stick can be sharpened with an artist's knife or by scraping it over a rough surface, so that the line, and therefore the degree of detail, becomes finer.

The Color of the Paper

If you want to show contrasts of dark and light, it is a good idea to use colored paper. The darker the tone of the paper, the more the whites will stand out when they are applied using a stick. If you are working with white paper the process is slower, as you must darken the range of tones more to indicate the contrast and volumes strongly. Another important factor is the grain or texture of the paper. Sticks of wax crayon and oil pastel are ideal for working on strongly textured paper. Paper textures can be utilized in strong and beautiful ways by juxtaposing very dense areas of color that have penetrated to the bottom of the grain with others in which the points of the grain remain visible.

> **MORE ON THIS SUBJECT**
> • Mixed Techniques p. 94

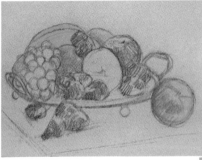

The first applications of wax crayon are made by searching for the general tones of each fruit. Notice that the darks and lights have not been given tonal values, as the darker colors will be added progressively. This is a work that progresses from light to dark. (Exercise by Joan Sabater.)

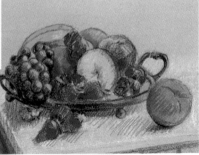

The shaded areas are established. For each element, the artist searches for a tone that coincides with the range being used, cool for the grapes and warm for the red and yellowish fruit.

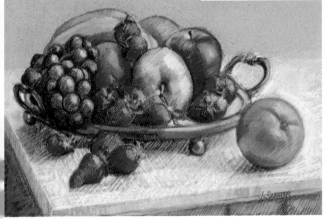

In the final result you can see the importance of working on a colored paper. Because of it, the white of the tablecloth and the highlights show up with greater strength. The color has not been blended, so both the strokes and the grain of the paper can be seen.

WATERCOLOR PENCILS

If one thing characterizes the technique of watercolor pencil, it is its capacity for being used both wet and dry. It can be used as classic colored pencil, or the pigment can be moistened with a paintbrush once applied. This characteristic is what makes watercolor pencils such a flexible medium, as it is possible to draw the model with an initial sketch, moisten certain areas, and then return to apply the pigment dry. As with conventional pencils, watercolor pencils are manufactured in a variety of densities for various effects.

Blended Tones Using a Paintbrush

To use soluble colors, lay down a color foundation with dry pigment, drawing in much the same way as with ordinary colored pencils. The more color that is applied, the more pigment material there is, the more water it will require to be diluted. Therefore, if you require an intense tone, it will be necessary to apply more dry color, while if you want a diffuse color, the amount of pigment required will be minimal.

To blend tones of watercolor pencil, once the dry drawing has been made, a moistened paintbrush is ap-

MORE ON THIS SUBJECT
• Light and Shade Using Colored Pencils p. 64
• Watercolor Basics p. 78

plied to the desired area. If you wish to add more color you can do so while the paper is damp, placing the point of the pencil of the desired tone on the damp area. After a few seconds the paper will have absorbed some of the pigment. If necessary, you can repeat the application.

Principal Contrasts

Whenever searching for contrasts, go back to the principles of color theory. By joining marks and areas of complementary colors, you can obtain strong contrasts that lessen or become neutralized as these colors are mixed with others. It is also useful to work

To begin your composition, draw the subject as accurately as possible using a pencil line. Establishing tonal values for darks and lights from the start creates form gently but clearly. (Exercise by Miquel Ferrón.)

Using colored pencils, color in the whole picture. The chromatic differences between the colors being used will tend to create adequate contrasts and will clearly depict the volumes and the characteristics of each element.

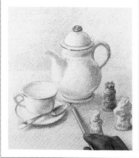

Notice how the pencil's pigment is dramatically strengthened when water is added.

The final effect combines precision of coloring and line. This is a mixed effect; watercolor washes are used when working with this complex effect. In the area around the objects, you can observe the smooth effect of watercolor and pencil texture.

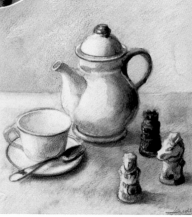

In this exercise by Myriam Ferrón, a violet pencil is used to make a sketch of the mountains and the layer of clouds that are visible as a horizontal form across the middle of the sky.

Warm tones are added to the gaps in the clouds and the lower part of the sky. The blue of the upper part of the clouds is colored in, as well as the dark areas in the foreground that stand out against the light.

Combining Strokes with Coloring

As colored pencil technique rests on combining strokes and toned areas of color, as well as brushwork, these three elements should be played off one another to create your composition. The strokes should be clear to indicate and emphasize volume.

A little water is added with a sable paint-brush, and immediately you can see how it increases the intensity of the colors.

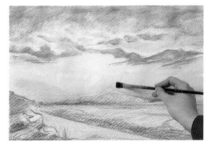

with the contrasts of cool and warm tonal ranges.

How to Maintain Highlights

Highlights using this technique are created in two ways. The first reserves the paper's background color, if it is the lightest tone in the composition, allowing it to function as the brightest area. The second way to establish highlights is with a dry pencil, once you have finished the drawing. Then retouch with a white pencil or other light tone.

Contrasts in the Final Version

In a drawing made with watercolor pencils, contrasts are made by alternating marks made with the pencils with washes made with a paint-

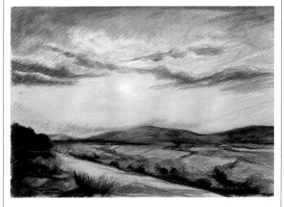

The final stage of the drawing shows how the diluted, washy color of the landscape is perfectly complemented by the strokes made by the watercolor pencils, demonstrating the strength of this medium.

brush. As it is such a versatile medium, retouching is possible when the work is almost complete, and is usually done with dry pencil. Then the outlines of forms are sharper, especially those most clearly defined in the foreground. The final strokes must be more

precise than those used to sketch the drawing out, to strengthen the drawing and highlight the interesting elements of the scene. For these reasons, the potential of the mixed technique for brush-work and point-work should be fully explored.

LIGHT AND SHADE USING PASTELS

Pastels are an excellent medium for beginners. Using one's hands to model forms is very useful to the understanding of form. Pastels vary from hard to soft, and both are often used in the same drawing to develop the form and design. This medium's great capacity for entirely covering a surface means that light and shade can be expressed directly rather than by reserving white paper.

A Different Color for Each Tone of Shading

In a pastel set that has a sufficiently wide range of tints and shades there are more light tones than dark ones. The tones mixed with white are more numerous because the technique of using pastels requires light tones to be laid on top of dark tones, similar to the use of oil paints. In works made with pastels, it is necessary to darken the general atmosphere sufficiently before adding the appropriate light points. There are many artists who begin by using black and white to establish all the values before adding tones of colors. Pastels blend easily with one another. The sticks of pastel pigment can be mixed together on the paper, both for purposes of creating light and for creating shade. These types of blends work very well to indicate shaded areas and all types of dark tones. Though because of inexperience beginners may make the mistake of creating dark colors using mixtures of dark brown or black, both colors can be mixed by using color that is better and more naturally integrated into the general coloring of a subject. If you

Superimposing Light on Dark

It is easy to obtain light colors using pastels, as the hues blend perfectly with white. You can also find a great number of pre-mixed light tones to use in your palette. The problem is not to obtain these luminescent tones, but to place them on the paper so that they fulfill their function correctly. Traditionally pastels are used by working from dark to light. One can start by coloring the darker areas freely, as the light colors will cover the darker ones. When you establish general tones that correspond to the volumes of an object, the light and dark colors can be used to create gradations to indicate mass and volume. When the light points are small and intense, it is not a good idea to blend them

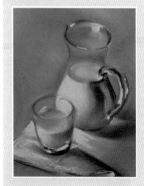

as this dulls their effect. Instead it is better to apply the correct tonal values to construct the form onto which the bright points will be made directly from the stick. Direct, unblended colors provide the greatest intensity that can be achieved with this material.

The light tones stand out, as they are brighter than the color of the paper. (Work by Vicenç Ballestar.)

The color of the paper is fundamental to the use of pastels, as one of the characteristics of this technique is the power of light tones over a darker background.

MORE ON THIS SUBJECT

• Practicing with Pastels p. 72

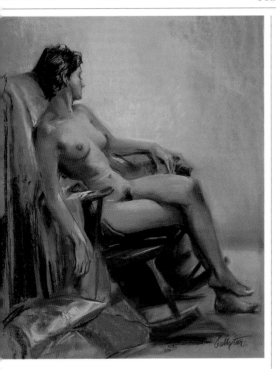

The figure and the portrait are two of the most common themes in pastel painting, and there is a great range of flesh tones that can be obtained. Each artist has their own methods for using these tones and for applying the pastel. (Work by Vicenç Ballestar.)

observe reality you will see that absolute black rarely exists, and that instead each dark area is influenced by the tones that make up the composition. With pastel sticks, it is easy to create areas of shading. As pastel has a great capacity for covering both the support and other areas of pigment it is possible to go over a dark color, not just to lighten it, but also to blend and vary it toward another tone.

tools are used to provide a general atmosphere, while variations in the atmosphere can be done with the fingers, as it is easier to model and work the shapes.

Blended pastel gives an impression of smooth transition, without marked differences between tones. An effective way to blend pastel is by using your fingers, though big blocks of color and general darkening of the painting can be done most effectively with a cloth that will easily work and fill larger areas. However if you want keep your tones pure, it is better to use the colors directly, with just a little modeling done with the fingers, as cloth will tend to smudge colors in surrounding areas.

When you blend pastels with your fingers, you can control the pressure with which the color is blended. When blended gently the color beneath does not come to the surface. When using the hands to blend it is easier to keep control of the area that is being blended, so that the surrounding tones do not smudge unnecessarily. Even so, pastels cover surfaces very easily, and can be retouched.

Blending with Your Fingers

Various tools can be used for blending pastels, varying from a cloth and a paper stump to your fingers. The former

Sometimes when using pastel, you can alternate the use of blending with the direct effect of the stick, achieving varied and dramatic results. (Work by Joan Raset.)

TECHNIQUE AND PRACTICE

PRACTICING WITH PASTELS

The first person to use the medium of pastels was Hans Holbein, in the sixteenth century, although it was not until the seventeenth century that pastels acquired widespread use, when they were adopted as the ideal technique for painting the portraits that Rosalba Carriera made fashionable at the court of King Louis XV of France. Colored pastels are a medium usually linked to Rococo art.

Coloring In the Initial Sketch

Working with colored pastels is one of the most relaxed tasks in the world of painting, since because of its nature, it does not have to be finished within a given time. Pastel sticks allow for spontaneous strokes and the easy coloring of relatively large areas. The particular qualities of pastel makes them suitable for fully developed works, and for sketches and quick studies. Area by area can be worked, and the color remains consistent. However, the work is fragile and needs to be fixed afterwards, like charcoal and chalk drawings.

Before beginning to apply color with pastels, it is necessary first to block in the scene. This should never be done with graphite, as it is incompatible with pastel, and so it is better to use charcoal or sticks of Conté crayon. Also, the paper should

have a medium-to-thick grain or texture so that the colors adhere to the surface well.

Pastel colors need to be used spontaneously, working from general forms to specific details. Once you have defined the model, you can begin to add color, always building the atmosphere of the piece and its large volumes. The painting is developed in layers, which can

An example of how pastels can be used in a drawing. Pastels are a very versatile medium that can be used for pictorial or sketch-like styles. When using a very restricted range, with a maximum of two or three colors, the effect is almost monochromatic. (Work by Francesc Serra.)

be sprayed periodically with fixative. General tones are simplified and can later be blended. Aim to simplify forms so that there are not too many elements in the background. It is important, when drawing with pastel, to work on the whole composition at once.

Separating Tones Without Mixing Them

Once you have established the general forms, the more specific forms can be represented by differentiating the tones without blending them. In this way you can give the composition form. Painting with pastel colors is always an exercise in making small progressive steps. It is a process of gradually making forms more concrete by means of the application of colors that become increasingly well-defined

Shade and the Impact of Color

Pastel is a dry, opaque medium that allows light colors to be superimposed on darker

Jean-Baptiste-Siméon Chardin, Portrait of the artist's wife. *The question of whether the work is a painting or drawing is one that has accompanied the medium of pastel ever since its admittance to the world of art. This portrait is undoubtedly a powerfully developed work with all the substance and stature of oil paints.*

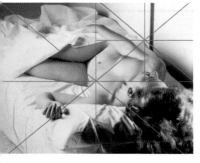

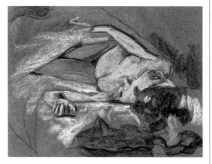

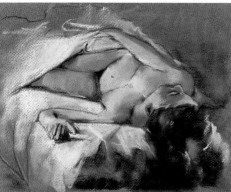

Here, as with all media, the picture is begun by blocking in the scene, aiming to make it as similar to the model as possible. A first general coloring is then made, locating the strongest volumes by using the pastels on their side. Next you can see how the colors have been blended, as is characteristic in a pastel work. Finally, the highlights and color effects have been added to complete the picture. (Exercise by Salvador G. Olmedo.)

ones without being destroyed. A light color block laid over a darker one makes the visible areas of the first stand out by contrast. The background of the paper used with colored pastels should be integrated into the general coloration of the piece.

MORE ON THIS SUBJECT

· Light and Shade Using Pastels
 p. 70

Edgar Degas, a Master in the Use of Pastels

Degas is one of the best known French Impressionist painters, particularly for his paintings of ballet dancers. But his great place in the history of painting is certainly partly because of his unequalled mastery of the medium of pastel.

For anyone undertaking the use of pastel, the study of Degas' figures is essential. Before Degas, pastel was considered a minor medium, used for sketching and study. Oil paint was the medium that commanded the most respect, and understandably so. But Degas' use of pastel revolutionized both the medium's use and its manufacture, and is considered the focal point for pastel use even in present times.

Degas used pastel on colored papers, which he used as a background for his figures, and which offset his powerful volumes and forms. This master used the medium of pastel to develop compositions of figures with all the stature, finish, and elegance of oil paint.

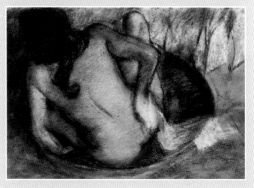

CHARACTERISTICS OF ACRYLIC PAINT

Acrylic paint has been in use for a relatively short time, and its existence stems from the need for a type of high-quality paint that uses a clean, fast-drying solvent. The pigments that are used to produce acrylic paints are very pure, and come in all the traditional colors. They are easy to mix and their color is as true as oil paints. Unlike oils, acrylic paint has a matte finish, but there are varnishes available that add shine to the painting once it is dry.

The Possibility of Working in Layers

Acrylic paint can be used either in an impasto like oil paints, or in a watery form much like watercolors, since the pigments are very strong. It is even possible to alternate both processes on the same work. Even with a generous amount of water, acrylic's pigment continues to be strong enough to color the paper, so it is not necessary to use an impasto technique to produce intense or vibrant colors. The more liquid added to acrylic, the quicker it dries, which permits the artist to work by applying successive layers, as with watercolors. When working in layers, you must always wait until the layer below is dry, or the paint will blend together or pull off the support. When one layer is dry, the color is given nuance with the same tone, or is intensified with another one. You can apply various layers, and then finish them off with an impasto of color. Water and impasto techniques can be easily combined to give a painting texture.

The Study of Light Using Acrylics

The degree of luminescence in acrylic paint depends on the type of method used to apply it. For very dilute treatments, light areas are produced from transparencies that allow the paper to show through. When working with an impasto, mixing with white will produce luminescent tones. Given that acrylic painting is a medium that has a number of possibilities, you can use several methods, and thus play with color and texture. Usually the beginning stages of any acrylic painting are done with very liquid paint, which is then thickened progressively. Very dramatic light

MORE ON THIS SUBJECT
• Creating a Work Using Acrylic Paint p. 76

points can be laid down with thick strokes of white paint directly, so that these highlights become more obvious and powerful than if the support had been reserved. When using a mixed treatment, it is best to depict light colors with an impasto technique, while darker colors do not require such dense coloring. In this way the bright, luminescent colors will create volumes and model form, conveying a sense of realism.

Waiting for Paint to Dry

It is vital to wait for the paint to dry when applying layers or washes. If pure tones are to be achieved without the influence of earlier colors, you must wait for the first stages to dry completely. If you don't wait long enough, the first color will come up and taint the colors painted on top. Blends should be made wet-into-wet and can achieve an effect that is as smooth and homogenous as oil, although the process will be quicker, as the drying time is much shorter.

Tonal Washes

Any water-based medium can be applied as a wash by adding water. This will add

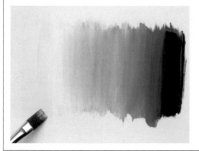

Notice the different ways of making a color gradation using acrylic paints, either by mixing it with white, or by using a wash. The result is similar in terms of luminescence, but the texture is entirely different.

Painting using the technique of impasto gives a sensation almost identical to oil paints, as the paint is thick and dense. Very lively textures can be produced, utilizing the changing direction of the brush strokes. (Exercise by Almudena Carreño.)

ight areas to blocks of more ntense, saturated color. Lighter tones are achieved through the effect of transparency, when thin coats of paint allow the paper to show through. Also, these new layers of luminescent tones will tend to be integrated and blended in with the darker areas. Washes should be done when the paint is quite diluted, similar to watercolor. If the acrylic is too dry it is impossible to make a

wash, as it forms a skin that attaches it to the paper. While the paint is damp its appear-

ance can be altered by adding water and rubbing it with a paintbrush if necessary.

Similarities to Other Media

Because of the relative newness of acrylic paints, research has been done to help the painter. The particular qualities of this medium make it comparable to watercolors, gouache, or oils. Similarities with watercolor occur when the paint used is diluted. Yet acrylic has the added advantage of using white to make bright areas as well as to add texture, more like oils. There are many similarities with gouache, as the colors are thick and opaque and can be used to create texture. Light colors can be added to dark as with gouache, although acrylic is denser and closer in texture to oil paint.

Similarities to oils are most obvious while it is still thick, with minimum water or straight from the tube. Acrylic's impasto quality can virtually duplicate that of oil paint, and like oil, it can be worked in various layers.

Superimposing Washes

Washes are made by applying one very transparent color over another, in such a way that the underlying color can be seen. It is possible to lay light colors over dark ones and vice versa. Most pure acrylic hues such as magenta, blues, and emerald green are very transparent. Because of the strength of the coloring, they can all be diluted with water. All the hues of acrylic, including the dark ones, can be applied one upon another. These glazes, or layers of wash, create fresh nuances, without the need to mix the colors previously. You can also make light washes on darker tones using the color white. As well as pure white, you can mix any other color with white. The result will be a pastel tone that will modify the underlying color. The color used to make the wash should be diluted with water so that the tones over which it is applied can still be seen.

Almudena Carreño has achieved a wash by applying a warm brown color to earlier tones. You can still see the yellows and violets because of the transparency of the wash.

CREATING A WORK USING ACRYLIC PAINT

Acrylics have replaced oil paints in many ways, especially because of their fast drying time, which allows the artist to paint works in the open air without any of the problems of transporting them that grease-based paints involve. The quality of paints and the cleanness of the material itself, both it its quick-drying application and in its diluted application, have made it the medium of choice for many contemporary artists.

The Composition of Acrylic Paint

Acrylics in tubes are the best quality on the market. The result is certain to be brilliant and rich in nuance. Wide ranges of pigments of high quality, all colors and intensities, are manufactured and the mixtures that result match oil paint in quality.

Although it is not common, some artists prefer to imitate the great masters of the past, and make their own paint, which is also a much more economical alternative.

To make you own colors, powdered pigment is required, which can be bought at many art supply sources. Prefabricated color pigment is generally of very good quality, but if you want very refined results for your mixtures, it is advisable to get the best and most expensive. For acrylics the medium to use to dissolve this type of pigment is acrylic agglutinate and a proportion of water, depending on the thickness you want.

Another way of fabricating acrylics is with latex, but this is a coarser, less pure agglutinate than the other. The better the quality of the materials, the better the result of the painting will be.

Searching for Tone with Acrylics

This is a medium with many chromatic possibilities as well as ways it can be used. Again, diluted acrylics can be used as watercolors. When used this way tones come from their transparency, and visibility of

MORE ON THIS SUBJECT

- Shadows and Light Direction p. 22
- Shade in Urban Landscapes p. 40
- Characteristics of Acrylic Paint p. 74

the background. When tones are mixed with white and a lot of water they will create pastel colors that are light and luminous. The glaze-like texture that is produced from this treatment is one that is characteristic of acrylic, creating tonal values by means of layers of paint and washes. If you are using acrylic as impasto, the result is very different. The light tones can be used on top of the dark ones, provided that the underlying color is already completely dry.

Acrylic colors can be made at home more simply than other media like oil or tempera. Be sure to put the paint in airtight containers, and in this way you will be able to prepare enough paint and preserve it for future work.

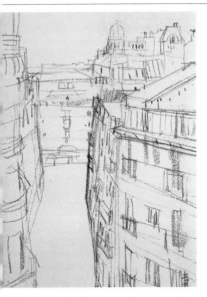

In this image, notice the layout of the scene, which has been done using charcoal. The rules of perspective have been treated loosely, which adds a painterly quality to the work.

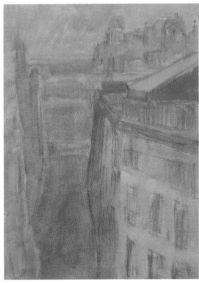

The appearance of the painting once the transparent background has been applied. This determines the general tone and constitutes a base on which it will be possible to build the painting.

Procedure for Working

The procedure for working is best done by going from dark to light, as with oil paints. As far as the blends and tonal gradations are concerned, for smooth surfaces it is recommended to apply the paint while the color is wet and soft, so that the colors can mix to create smoothly transitioned volumes. If the color dries out, the tones should be applied using direct, impressionistic brush strokes, as there is no way of recovering its dampness. It cannot be reconstituted like watercolor. Its composition is synthetic, so each application forms a film that fixes itself to the paper and cannot be altered.

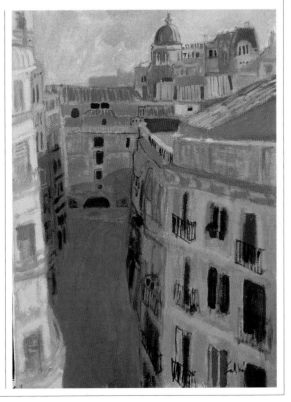

In the final stage, Muntsa Calbó has progressively added an impasto of paint. In the background and sky you can still see the dilute, transparent color. The thicker, textured areas are in the more foreground. The more concrete detail is made with a fine paintbrush.

TECHNIQUE AND PRACTICE

WATERCOLOR BASICS

Of all the possible pictorial techniques available, one of the most difficult to master is watercolor, because it is so immediate and depends on the flow of the paint, which is mostly water. With watercolor, the artist has less control over the material of the paint than with other media. Its great fluidity means that many factors escape the intentions of the artist, and behave unpredictably, although this aspect is also one of the great attractions of the medium.

Watercolor Basics

Whichever technique is chosen for representing any given theme, the first steps must be based on a knowledge of the medium and of its characteristics. Of all the different brush techniques, watercolor is the most spontaneous, and the blending of color is immediate provided that enough water is used. It is an ideal medium for representing landscapes, skies, and natural forms that do not demand a specific formal ordering. For these subjects the paper can be moistened and tones and brush strokes applied that will flow and blend over the surface. Later, when the paper is dry, you can go over areas and depict more concrete forms. With enough mastery of the material, any subject can be portrayed. However, to represent precise, detailed figures it is

Tonal Gradations Using Watercolor

There are various ways of achieving tonal gradations using this technique, although there are two main ways of working with watercolor: wet-into-dry and wet-into-wet. Watercolor is painted wet-into-dry by allowing each layer of paint to dry before applying the next one, so that the paint does not blend. This method creates clear changes of tone that follow the outline traced by the paintbrush. Tonal gradations are made by changing the intensity of a tone in relation to the color next to it. The resulting coloring will appear in flat modeling form without blending. When applied wet-into-wet, watercolor creates blends and smooths gradations. When the paper is damp, or if many colors are applied without allowing each one to dry, they mix according to the movement of the water on the paper.

When applying a brush stroke, the intensity of the color is greatest at the beginning, and diminishes as the mark is extended. This produces a gradation without the need to add water.

The grain or texture of the paper in a watercolor is fundamental when making a brush stroke, influencing both its form and the final result of the work. Fine-grained paper produces clean, sharp brush strokes, while thick-grained paper can distort the original form of the stroke.

MORE ON THIS SUBJECT
• Watercolor Pencils p. 68

necessary for each layer to dry before applying the next, to work with greater control. Because it cannot be erased or corrected, make an accurate pencil sketch before adding color, as once the paper has been colored, the image is set.

The Absence of White in Favor of a Colored Background

Watercolor is applied using transparent washes. It must always be applied in diluted form, since, unlike oils, it cannot be worked when it is more solid. This is because the grained paper itself is highly absorbent and requires enough water for the effects of brush strokes to show, along with areas created by the flow of the paint itself. Watercolor technique consists of painting transparent washes that allow the background paper to remain visible. Darkening is achieved progressively, and whites and luminescent colors are created by using few applications of paint.

Again, the proportion of water to paint determines the intensity of the color. The tones closest to white should be made with very little pigment, so very light tones are created, which can later be intensified if necessary.

Dark on Light

Any technique consisting of applying transparent colors must be used by painting dark tones over light ones, in a process that progressively darkens the coloration of the piece. With watercolor, there is also a general absence of white, so light tones must be established using

a lot of water, letting the paper color show through. Applying color is usually done on a previously drawn sketch made with pencils or watercolor pencils, over which the general coloring and washes can be made. The colors blend together to fill the paper, creating the first layer. Once the initial base is dry, the color becomes less intense, but the piece can be worked on and highlighted with fresh additions of color. The degree of darkening can only be assessed once the color is dry. When watercolor is wet, it tends to look more intense, and it is often necessary to go over it several times until darker tones are achieved.

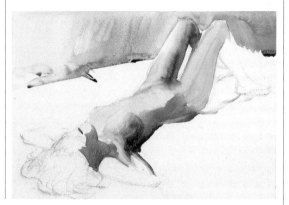

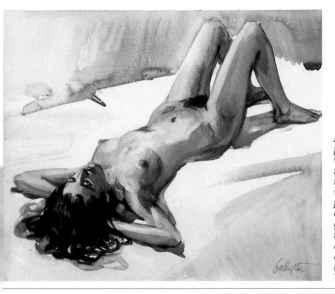

Any subject portrayed using watercolor requires the artist to reserve the whites of the paper in the areas of light, and to gradually intensify the paint to achieve medium and dark tones. (Exercise by Vincenç Ballestar.)

ADVICE FOR USING WATERCOLOR

As one of the oldest and most commonly used techniques in painting, watercolor is also one of the most rewarding, and the most flexible. Each painter can use watercolor in a different way, applying individual creative methods. It is a medium that can be easily combined with pencils and water-based felt-tipped pens. With oil-based media or wax crayons, it can produce surprising results.

Colors That Should Be Avoided in Shading

The best watercolors are those that come in tubes. The strength of pigment is maximum and the mixtures that result from it are as pure as if they were made with oils or acrylics. Mixtures with watercolor, in contrast, are more difficult to control than with other, more versatile, media. For shading it is common to use blacks or dark browns, as they establish an intense degree of darkness with ease. However, this is not as simple as one might imagine, as blacks and browns tend to be warm and often need to be toned down with violets and blues. In addition, the color black is always very extreme when used for creating shade, and it often taints the coloring in general, especially if the watercolor is damp, since the effect of the water will allow the black to mix with the other, pure colors. Because of the pure quality of the paint, it is possible to make effective mixtures of colors, and blacks and grays can be mixed to establish shaded areas. Mixing such blacks and grays is often prefer-

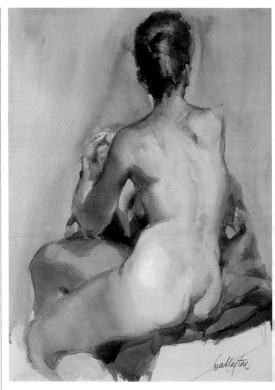

The degree of representation that can be achieved with watercolors is amazing. Ensuring that the initial sketch is correct is the best guarantee of a good result. (Work by Vincenç Ballestar.)

With the primary colors plus black or sepia, you can create all the ranges possible. The mixture of the three primary colors produces a dark, black-like color, so the use of black is not absolutely necessary.

able to using black from the tube. The dominant tones and hues of the composition can be used in these mixtures, which will also serve to unify the work.

Using Washes

Washes are made by intensifying or varying a tone by applying layers on top of one another. Most brush techniques

Masking fluid is the safest method for reserving very specific highlights. (Work by Ana Manrique.)

allow you to use this method. The only prerequisite to do so is that the first layer must be dry. Washes can be made with acrylic, with gouache, or with oils, but they are most common with watercolors, as the quick drying time allows successive layers of paint to be applied more immediately than with other media. When washes are made, they must be done on dry watercolor. If you want to change or highlight a color with the same tone, except stronger, or with a different tone, it is necessary to wait until the color beneath has dried, since, if not, it will produce a blend and not a wash. The result always depends on the principles of color theory. Colors in the same range, warm or cool, are strengthened by applying a wash of the range. Colors of complementary ranges will be neutralized to create a series of neutral and broken colors that can be super-imposed on one another to create shading.

Striking Highlights

Reserving whites consists of leaving the paper uncolored. The more concrete the high-light that has to be depicted, the more meticulous the artist must be in making the reserve. Striking highlights can be seen in very specific materials and the objects made of them, such as glass, metal, or any smooth, polished surface. Textures such as these are typically found in paintings of still life. Shine and highlights are also found in water, in landscapes, and skin that is wet, which usually gives off strong, bright reflections. In cases in which the highlight is small and specific, the use of masking fluid can be helpful. The brush for masking fluid must be made of synthetic hair, as the liquid is very corrosive, and would destroy the soft sable hair in brushes that are used for watercolor painting.

MORE ON THIS SUBJECT

· Watercolor Basics p. 78

Making Negatives

This is a process using watercolor technique with contrasting, oil-based techniques, such as wax crayons or oil pastels. This way of working is called mixed techniques because the solvents of the materials are different and non-complementary. A negative is made by using a stick of wax crayon to reserve an area or shape to be highlighted. When the watercolor is painted over it, it won't penetrate the areas covered with wax crayon, which will remain a white, bright area seen in relief. You can use white wax crayon to highlight pure points of light, or you can apply complementary colors with wax and watercolor, and in this way create all types of effects.

White wax crayons can be used effectively for reserving points of light in watercolor, which is totally resistant to the application of water.

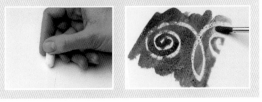

COMPLEX SHADE WITH WATERCOLOR

Sight is possibly the sense we use most, but it is not very efficient where shade is most pronounced. It is always a challenge for the artist to distinguish the tones in nature, since the human eye cannot really see more than three or four tones in an area of shade. This is particularly challenging for a beginner as it takes time to develop observation skills, particularly regarding the nuances of shade. But the representation of tonal distinctions within shade makes a picture rich. With keen observation you will learn to discern these subtleties, to build shadow and form that will be readily understandable by the viewer.

Representing the Light on Everyday Metal Objects

Objects made of metals have been part of daily life since ancient times, so it is not surprising that they are often the subject of paintings by the world's greatest artists. A cooking utensil, a sword, armor, the modern vehicle, and so on are elements that have been the subject of the most varied representations.

In general, metals are represented with ranges based on the color burnt sienna and on a series of grays, depending on the type of metal and the state it is in.

The color gold, like almost all metal textures, cannot be represented literally. But of all the metals, gold is without a doubt the most difficult. Normally a range of colors, with a base color of yellow ochre, can be used. The tone should be varied as the color is nuanced with other colors as varied as crimson, green, blue, sienna, and red.

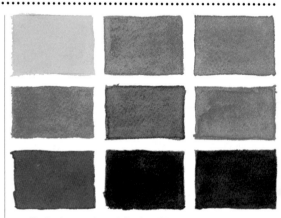

The basic range for painting in gold using watercolors. It is a range that goes from yellow ochre to burnt umber.

Complex Textures

There is a series of tonal ranges that are useful in the depiction of different textures. This holds true when representing antiques. For example to represent the rust on metal, it is useful to use a tonal range that results from the mixing of burnt sienna with pink. Metals can be represented by means of an extensive range of blends that are based on burnt sienna and cobalt blue.

Yellow ochre and burnt umber can be used to represent a multitude of surfaces that

An example of gold tones being used in the representation of an Egyptian funeral mask. Notice how the highlights are achieved by making yellow ochre the lightest tone in the range.

have been exposed to the elements, whether metal or wood, although for the latter it is better to use a mix of Neapolitan yellow rather than yellow ochre.

For architectural elements the range of groups that result from the mixture of vermilion and ultramarine blue are very effective.

For all these mixtures it is best to use the lightest tone as the brightest highlight, the tone or mixture closest to the color of the paper, and use it to represent the degree of maximum light.

MORE ON THIS SUBJECT
· Watercolor Pencils p. 68
· Watercolor Basics p. 78

Glass Volumes

Glass in all the forms it may present itself, is very difficult to represent, as it is colorless. It is always important to study the model carefully before trying to represent it. The colors that surround the glass object will be clearly visible through it, and will become the means by which the transparent surfaces of the object can be represented. Glass objects also have the capacity to reflect light, and highlights are usually ever present on their surfaces. Images are also reflected in the surface of glass that become a part of the representation.

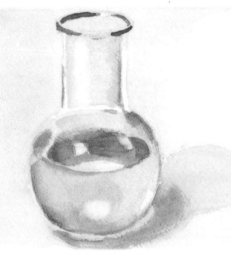

The transparent glass shows everything that is behind it. When working on a white support, you can place the highlights, and use the background of the paper if they are left white.

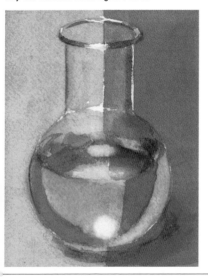

The previous image, but with a red and orange background. Notice how these colors are reflected and refracted on the surface of the vase, and how they are distorted following its outline.

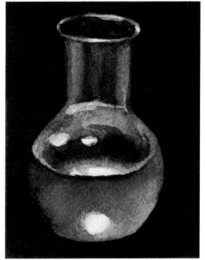

If you place a glass receptacle on a completely black background, the reflections will be even more intense because of the principles of the law of simultaneous contrast, lights appear lighter when surrounded by darks and vice versa.

THE TECHNIQUE OF GOUACHE

Modern-day gouache is nothing more than tempera that is packaged and marketed. During the Middle Ages, tempera paints were used on wooden boards that had been prepared with glue so that the paint was absorbed, fixed, and conserved by its own glue. Nowadays chemical advances make it possible to manufacture gouache with preservatives, so one can paint on paper with it, confident that the paint will be well-preserved.

General Characteristics

The qualities of gouache paint are quite unusual, as it is a medium that is halfway between acrylics and watercolors in thickness. It can be used in a very dilute form like water-color, although its texture is thicker, yet not so thick as acrylics.

Tempera paints are available commercially in various forms. You can find them in plastic or glass jars of all sizes, from large jars for use in schools to very small ones, with concentrated pigment. They are also available in pans, like watercolors. In boxes of gouache pans the color white is not included, as in this state it is not very opaque. To use it, it is necessary to buy it in a separate tube. Tempera paints in tubes, or gouache, are the most professional available and is the form is which the purest

First the dark tones are established, corresponding to the rocks. Dark browns and intense, dark sepias are used.

In the areas of the sea, white areas of the color of the paper are left to represent the distant shine of the water.

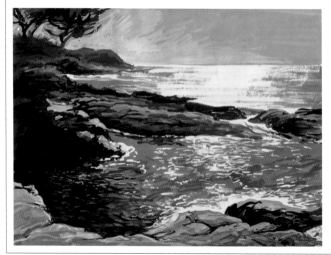

The finished result of this combination of light and dark creates a highly contrasted effect. The whites in the distance correspond to the color of the paper, while in the foreground they have been done with an impasto of paint. (Exercise by Miquel Ferrón.)

and most concentrated pigments are found. A small tube of gouache goes as far as a tube of watercolor.

Advice for Using Gouache

The ideal surface for painting with gouache is a simple, medium-grained, medium-porous paper. Very glossy paper is not as good, as it does not absorb the paint, and tends to make it run. Watercolor paper, on the other hand, is too porous, which makes it difficult for the paint to slide over the surface. As for the thickness of

the paper, it is best to use the heaviest possible, even though gouache dries very quickly. If the paper is thin, the paper can crease or buckle while the paint is still damp, even if it is held rigid. If you use a very thick paper, or illustration board, it will not warp and the result will be smooth and perfect.

The ideal paintbrushes for painting with this type of paint are of synthetic hair, with characteristics halfway between pine-marten, which is too soft, and pig bristle, which is too stiff. With this type of brush you can control the stroke or mark perfectly, regardless of how

much paint you are using, and you are also sure of not getting marks from the hair, since it is much more flexible than pig bristle.

The Finished Result

Gouache is very useful for painting works with simple blocks of color, which is why in its commercial tempera form it is so useful for children. It is slightly transparent and the colors are not as opaque as acrylics, so when applying a light color on top of a dark one you might have to apply several coats. Another characteristic of this paint is its lack of shine. A gouache surface is always matte. Nevertheless, because of continual experimentation with its chemical composition, some brands available in tubes give a shiny result when applied thickly, though not when diluted with water. If a shiny surface is wanted however, you can always finish the painting with a layer of spray varnish, which will give it a deep, glossy finish.

To achieve flesh tones, you must bear in mind the difficulty of blending with this medium. To do so successfully the paint must be wet, so that the different tones can merge.

The sofa is painted using orange and yellow tones, throwing the figure into relief. The tonal warmth of this element causes the tone of the figure to appear more neutral.

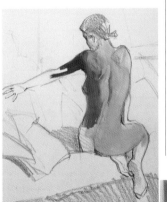

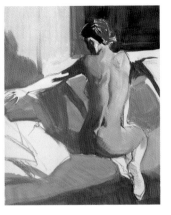

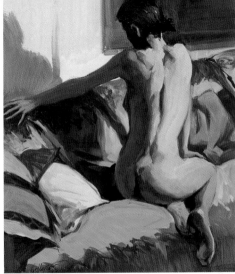

The picture is completed. For the most intense tones, sepia is used directly. The picture is a contrast between light and shade. (Exercise by Vincenç Ballestar.)

TECHNIQUE AND PRACTICE

EXPRESSING LIGHT WITH OIL PAINTS

Oil painting offers a degree of representation that cannot be attained using any other medium. Its capacity for blending and the time it takes to dry allow the artist to work the paint slowly, until the degree of realism that skill allows is achieved. The sequence for working with colors is the same as for pastels, moving from dark to light. White, which comes in very large tubes, is important for mixing in order to achieve tonal nuances.

An Indispensable Medium

Ever since oil painting was discovered by the Flemish masters during the Renaissance, the medium has been unequalled for its representation of reality. The medium's use spread quickly to the rest of the world. Oils are known for their malleable nature, and their great capacity for blending and permanence. Because of the long time it takes to dry, oil painting soon reached a degree of perfection and realism that could not be surpassed, even with the passage of the centuries. Nowadays it is still a favorite technique among artists, especially those who tend toward figurative painting, as it represents the ideal medium for faithfully and realistically depicting the natural world. It is true that there are now other media, such as acrylic paints, that similarly offer a high degree of representation, yet with oils the results are bright and luminescent, whereas with acrylics they are more dulled. The quality of oil color is also better than that of other media, and its capacity for blending and mixing is unsurpassable.

The Chromatic Capacity of Oil

Being one of the oldest and most widely used materials, oil paint has reached high levels of perfection. The method of producing oil paints is the same today as in the past, but now commercial production brings with it cost-effective manufacturing. One helpful method or procedure is to establish a tonal scale as you

prepare to paint, which will allow for exploration of colors to be used later to develop the painting. With oil painting it is possible to accurately reproduce all the colors found in nature, and history has already done so. In the time of

Caravaggio, dark browns and blacks dominated, creating strong contrasts and blends expressing the dark, pessimistic mood of the era. Impressionism saw the explosion of pure colors and the depiction of nature at its most lively and vibrant. Every imaginable scene has been depicted in oils since its advent. The quality and strength of oil color rests on the pigment's suspension in its oils and resin.

Michelangelo, The Holy Family. Uffizi Gallery, Florence. Ever since the Renaissance, the greatest works of art have been produced using the medium of oil paint. The great capacity for oil paints to blend together makes the effects of realism much more dramatic than with other media.

Colors to Avoid in Shaded Areas

All chromatic ranges used in a work depend on the coloring of the whole work. Colors are interrelated, so depiction of shaded areas depends on the other colors present, both intense and neutral. The first point is the general atmosphere of the picture. A diffused light produces effects without much contrast, so the shaded

MORE ON THIS SUBJECT
· The Process of Applying Oil Paints p. 90

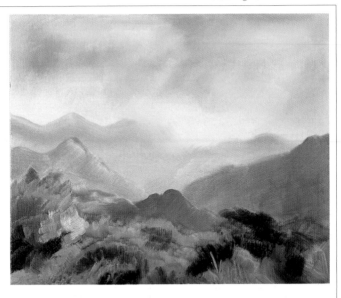

Oil paints have very high-quality pigments. Pure greens, blues, and violets have been some of the most difficult colors to obtain because they are made by chemical processes. With oil paints, cool tones can be obtained that are as vibrant and clean as warm tones. (Work by Miquel Ferrón.)

areas should be mixed with intermediate tones to neutralize them. Dramatic effects of darks and lights require more intense values, and shaded areas will be portrayed by adding darker tones to the palette. Yet, this effect should be carefully graded to not produce monochromatic tones. Dark brown and umber are used to darken warmer tones and flesh tones, but are not recommended for cool color ranges.

Colors to Avoid in Bright Areas

The color white in oil paint is strong and thick, and easily brightens color and tone. Mixing with liberal amounts of white will result in pastel tones. But too much white can dull color. To avoid this effect, other colors can be used to model form. When working with cool colors, the pastel effect can be avoided by controlling the gradation of tones. With warm colors, you can avoid the pastel effect by adding yellow instead of white, which does not lighten the color as much as it brightens and warms tone, instead giving colors a certain liveliness. Yellow cannot be used to lighten cool colors, as it will instead make them neutral, or gray.

Luminescent and darkened colors form part of the chromatic range of this painting. These warm tones contain a variety of browns and umbers to darken the coloration of the reds and oranges. (Work by Miquel Ferrón.)

MIXING OIL PAINTS

The technique used for mixing colors when painting with oils depends on the stage of the work. The early stages of a painting have to be made rapidly and effectively, and many of the mixtures and values are made on the canvas itself, with the intention of giving the painting an initial general feel, and of covering the whiteness of the canvas, which otherwise might fracture the image. Later nuances and mixes are usually made on a palette, in order to be more certain of them, although they should then be applied to the canvas to be verified.

Colors for Light and Shade

In this type of medium, all the colors, both light and dark, are thick and non-transparent. When referring to light colors and dark colors in oil paint, it is the amount of light each color contains on its own that is meant. Tones of yellow, ochre, oranges, yellow-greens, and all

tones that are mixed with white appear light in the range of colors and will work for light areas. Blues and purples in their pure form tend to be dark in appearance, though they will lose strength when spirits are added and the paint is thinned, or when it is mixed with a little white. A variety of colors form the darkest range, most of them in the category of deep browns.

Umber and dark browns read the darkest apart from black. Browns and umbers are easily integrated into the warm range working as tones. Cool hues are dark of their own accord, and to intensify them they should be mixed with black, as dark browns tend to neutralize them too much because of their warm character. Black, like white, provides the most extreme tones in a range. White is the easier to grade in mixtures, while black takes more careful control because it affects a color more heavily.

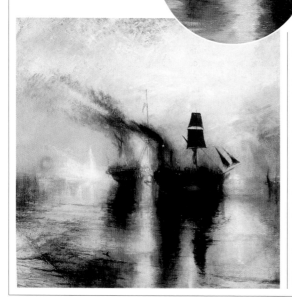

J.M.W. Turner. The most dramatic colors to use for contrast are clearly black and white. However, they are rarely used directly. Dark colors are usually made with the influence of black, but by mixing other tones. Direct white is used for very specific bright points, and it is usually broken with a blue or a yellow, depending on the texture being represented.

Direct Mixes and Studying Tone

The direct observation of reality is very important when mixing colors. There are no formulae for mastering color mixing, and intuition plays a big role. Previous knowledge of color theory will answer many questions relating to obtaining colors and tones. The chromatic table or color wheel establishes a series of relationships between colors that will help your understanding of possible mixtures. Broken or neutral colors and browns are achieved by mixing color opposites. The least influence of one color on another gives it a nuance in such a way that the possibilities available are unlimited.

Although it is necessary to study the model in order to determine the coloration of the painting, there are certain tones that are used in general.

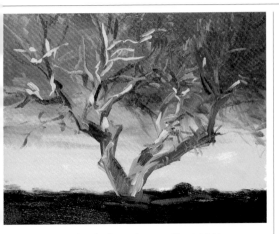

Complementary coloration is very important in establishing contrasts. Oranges and blues, for example, create a very strong and dramatic contrast. (Work by Miquel Ferrón.)

For flesh tones, for example, ochre is usually mixed with white or brown. Depending on the color of the model's skin, it may be necessary to add a little pink or red to the mixture. Some manufacturers of paint offer a flesh tone to use directly from the tube, but it gives a very artificial appearance. Tones of umber and dark brown combine very well to darken flesh tones, while cool tones added to flesh tones with elements of brown and red offer a more contrasted feeling.

Lightening or Darkening a Tone

Lightening or darkening a tone consists mainly of mixing it with other colors, and is not simply a case of adding black or white. There are various ways of modifying the intensity of a color. Adding a little black will easily intensify and darken

a tone, but often the nature of the tone itself is so altered by adding black that it is a good idea to think about other alternatives. It is usually a better idea to mix colors with dark browns for shadows, so that they remain in the same tonal range. Black can be used in very small quantities, since it so heavily affects colors and may completely dominate. Blues and violets are fairly dark and if no white is added to them they can be as intense as darker colors. Mixing entirely complementary colors produces very dark tones that can be combined with any other color to establish a more controlled shading than with black. To

lighten colors, one cannot avoid using white. It is an essential color for the palette and the one that is most commonly used in mixes. Although colors become softer when they are mixed with white, the result can be controlled. If you use only a little white, the tones will be lightened but will still keep their purity.

Working on a Painting

In other techniques that are not so opaque, it is possible to work on a bit at a time, or by superimposing layers. With oils, on the other hand, it is possible to change things freely, as one does not work in layers, and if the color is accurate, the tones can be laid in right from the start. The important thing is to take into account the entire painting and to work on it as a whole. Since oil takes a long time to dry, it can always be altered and retouched until it reaches the required level of representation, especially in the elaboration of tones. While the paint is still wet and workable it can be blended and you can integrate new colors into earlier applications. Soft paint favors blending, but there are also some difficulties, especially when light colors are added to dark colors, or when very contrasting colors are mixed. In these cases, it is advisable to wait until the paint is dry.

Darkening tones always depends on the general tonal range being used. To depict flesh colors, light and shade must be perfectly integrated. Only in this way will the skin acquire a smooth, realistic feel. (Work by Miquel Ferrón.)

MORE ON THIS SUBJECT
• The Process of Applying Oil Paints p. 90

TECHNIQUE AND PRACTICE

THE PROCESS OF APPLYING OIL PAINTS

Oil painting is a medium that comes from Northern Europe. Ever since its discovery it has found many skilled practitioners, until eventually its usage has become very widespread. The painter responsible for introducing oil painting into European art was Jan van Eyck. The greatest practitioners in the evolution of the medium are two Baroque painters, Velázquez and Rembrandt. This move to oil painting was not just a passing trend, but a revolution. It is a medium with tremendous power and an astonishing range of possible techniques.

Sketching in Shade Using Turpentine

When beginning an oil painting, start with some basic steps. First make a sketch that outlines the scene you want to represent. This sketch can be made in charcoal or with a fine paintbrush dipped in a mixture of turpentine and a little sepia or natural umber. The choice of one or another method depends on the subject. If you draw several elements, it is best to use charcoal; if the object has few details, you can use a paintbrush. In the final instance it will, of course, depend on your own taste and preferences.

Once you have sketched the model on the support you can then apply turpentine. The first application is painted along the lines you've initially blocked in. Then turpentine is applied more liberally to extend the wash of paint or charcoal to find the volume of the forms by means of shade. This application of turpentine can be done using a little paint and adding medium, either linseed oil or some other oil medium, to make the lighter areas of shade, or by using less turpentine to make the darker ones. At this point, begin to accentuate the contrasts. The color chosen for the initial study should be appropriate to the subject. The application of turpentine will provide initial tonal values, building a foundation over which to apply the definitive gradations of light and shade.

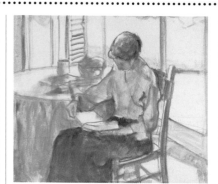

Notice in this case how a monochromatic study is made, and how the intensity and quality of the light and shade of the composition are established. (Exercise by Badia Camps.)

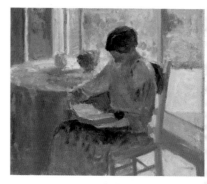

In the second stage, the artist lays down a "bed of paint." In other words, the correct tones are found by approximating and building them, and painting them over the monochromatic study.

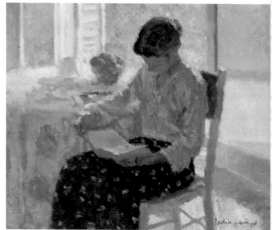

The finished work by Badia Camps.

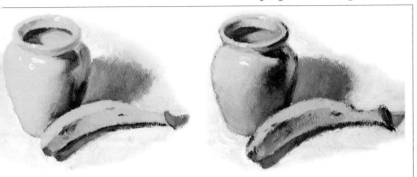

An example of the use and abuse of black and white to lighten or darken a color. Notice how the colors become tainted and overpowered, in this case tending toward a greenish color (left), due to the mix of black and yellow. Here other colors have been used (right), rather than black and white, in order to give the local color and tone nuance. Light and shade are expressed effectively without overwhelming the subject. Notice how pure white is used to bring out the highlights.

Opening Up Light Areas

When you undertake a painting in oil, you will need time and patience. Oil is not a technique for applying quickly, especially if you want to make washes. The use of oil requires patience because it dries very slowly.

Normally, whenever you apply color using oil paints, the lighter areas are left without being sketched in turpentine. After applying the turpentine the work still shows large areas of color, never beginning with the details. When you have decided which areas should be the lightest, you can continue with the coloring. Sometimes light areas are covered with light colors, so that later a wash can be applied over them that will enrich their color, but always allow the first layers to dry properly for this to be effective.

The application of highlights can be done with a paintbrush or spatula to finish the painting. White is usually added to mixtures and is used to accentuate the brightest highlights.

Deciding on a Theme

When preparing to paint a picture, there is one obvious question: What can I paint? To make this decision it isn't enough to choose subject matter that is appealing or even beautiful. It is important to consider a strong approach and composition in order to get the most out of the scene aesthetically.

The most important part in choosing a subject is how to frame it effectively. The possible subject matter is varied — portrait, figure, still life, landscape, seascape are just some of the possibilities; painting history offers an endless variety of examples. Some advice: Always aim at the simplification of what you see, especially when you are new to painting.

Monochromatic Study

Monochromatic studies are very similar to turpentine sketches, because they start off from the same point. A monochromatic study of a model is an excellent exercise in tonal gradation, or in other words in light and shade. Normally these studies are made in the first sitting when painting with oil, so that in the second session you can continue by developing the color.

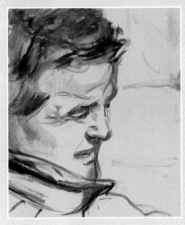

This is a correct monochromatic study that will serve as a foundation for a more developed study to be done in a later session. (Work by Yván Viñals.)

MORE ON THIS SUBJECT
· Expressing Light with Oil Paints p. 86
· Mixing Oil Paints p. 88

DEVELOPING SHADE USING OILS

Without doubt, oil paints are a grand medium. Their range is so great that they can be used to depict everything from the voluptuousness of human flesh to the cold hardness of metal. The medium of oil paint command more respect than any other. It is so flexible that any texture can be represented with great accuracy. The effects that can be created using this medium are surprising and its versatility opens up a huge field for the artist to work in.

Establishing Shade

Figurative art and abstract art are very different. Figurative art displays every contrast and composition of light and shade, based on the way light falls on objects in nature.

In abstract art, the creative task of representing dark colors depends entirely on the context of the work. The composition of an abstract work is based on balance of volume, shape, color, and line. There is no requirement of reality for the use of darks and lights. The composition is achieved by means of the pure power of color and form.

At the same time, chromatic concepts established in conceptual works are also found in naturalistic paintings. Scenes from daily life present an interplay of light and shade that the artist needs to understand and learn to express. An effective handling of light and dark is required whether a painting is abstract or representational.

Points of Maximum Shade

No two compositions, even of the same objects, have the same characteristics, and so there is no formula for light and shade, as they will appear with different intensities, depending on the individual piece. When working with subject matter, its entirety must be studied in order to understand its tones in terms of the darkness of the shaded areas. Half-closing your eyes helps to

Notice the variety of ways that exist for establishing dark shades. In A, Esther Serra has sought dark brown and black tones to create shade based on strong contrasts. In B, Miquel Ferrón defines shade using bluish and cool tones that contrast with the warm surrounding light, particularly because the colors are complementary.

A

B

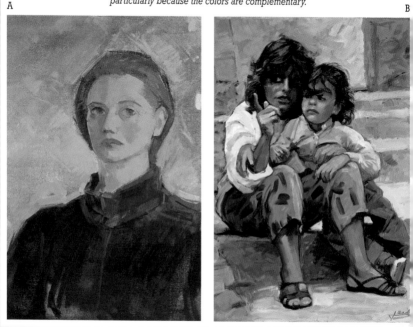

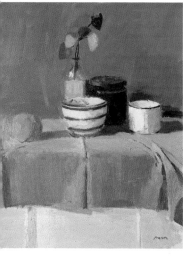

An example of how colors can be shaded, without the need for pure black. Notice how the colors have been given nuance by standing out in relief against darker tones. In this painting, a careful study of the light and shade gives us a clear impression of the direction and intensity of the light. The darkest shade is located in the center, between the three objects that block out the light. (Work by Pere Mon.)

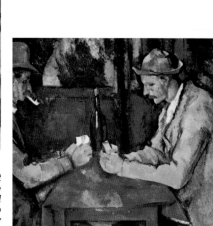

Paul Cézanne, The Card Players. Impressionist Museum, Paris. This is a perfect example of the use of simultaneous contrasts. The background and the outlines are darkened or lightened to highlight the figures, using a treatment entirely based on tonal values.

establish the correct relationship of light and shade, as many details disappear that often add a confusion of detail in establishing the main blocks of color. The darkest areas of shade are created in the areas opposite the light source. These dark areas are normally concentrated in the backgrounds of large rooms, beneath tables, or in the interior of receptacles.

Whenever we refer to the maximum points of illumination of light or the deepest shade, it is necessary to go back to the principles of simultaneous contrasts: a color is darker the lighter the colors that surround it, and vice versa.

Modeling Shade

Modeling by means of shade is a form of painting that focuses on tonal values. In other words, painting that is based on a series of tonal gradations gives the artist the opportunity to construct volumes on the basis of a study of the amount of light that passes over the surface of an object.

Shade should not be thought of as a block of muddy, imprecise color, as it may seem to be when one begins, as shadow is rich with nuance and can be the strength of a composition. Shade consists of a broad spectrum of one color. It is much like stepping into a dark room, and the eyes only gradually discern more and more details in the darkness. In the same way the artist must learn to discriminate between at least two or three tones within an area of shade. This way of studying shadow will make a work become dynamic.

MORE ON THIS SUBJECT
- Expressing Light with Oil Paints p. 86
- Mixing Oil Paints p. 88
- The Process of Applying Oil Paints p. 90

Compensating for Highlights

It is rare when working with oils that you will need to adjust the highlights, as they are always added in the final stage of work. However, if you should have to, there are various ways of dulling highlights that interfere with a composition. The first consists of repainting the area, once it is dry, and applying the highlight again correctly. The second method is to place lighter colors around it, although too many lights will negate the effects of the highlighted area, which will only work as light if it is the brightest point.

Wash tones can be used on top of bright areas that will reduce the vibrant tone bringing them under control.

MIXED TECHNIQUES

These are innovative and original techniques that stem from the artist's need to investigate and search for new and different effects that are different from traditional techniques. Traditionally new combinations of materials are used, which become standard, widely practiced techniques. Invention is part of art, so personal investigation should never be ruled out for the achievement of new and different forms of expression.

The Most Common Mixed Techniques

When referring to mixed techniques we mean the mixing of different media on the same support. This can be done in two ways, either by mixing dissimilar materials or by mixing similar ones. Dissimilar materials are materials that use different solvents. The effect of this process is one of contrast, since one type of paint naturally repels the other. One example is the use of wax crayons or oil pastels and an application of a wash of ink or watercolor on top of it. The forms created with grease-

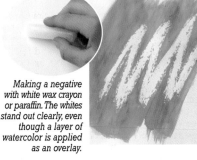

Making a negative with white wax crayon or paraffin. The whites stand out clearly, even though a layer of watercolor is applied as an overlay.

based media repel the water, and bleed through, revealing the original drawing. The same process can be used the other way around, first applying a base of water and then ap-

plying strokes of wax crayon on top of it. You can work applying a grease-based medium on top of damp paint and it will adhere. The effect of mixing water and oil-based media

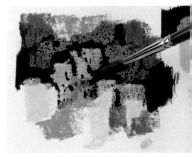

A waxy negative using various colors. Despite the direct application of ink, the underlying color comes through in all its intensity.

Using turpentine. The application of turpentine dissolves the wax crayon as if it were watercolor. This is an ideal method for combining a blending technique with line.

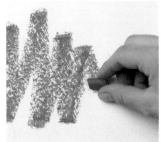

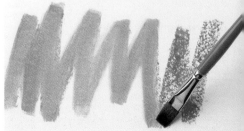

Sgraffito. This is achieved by applying a layer of dark wax crayon over a lighter layer. If you scrape away the second layer with a knife or point, the underlying color shows through.

MORE ON THIS SUBJECT
- Creating Tonal Values with Felt-tipped Pens p. 62
- Working with Crayons and Oil Pastels p. 66

creates negative forms. As for the combination of more similar media, it is possible to combine oil paints, wax crayons, or water-based media with materials such as colored pencils, felt-tipped pens, or ink.

Combining Dissolved Crayon with Strokes

There are different ways of handling the working of media and the combination of ways can create an effect of variation and mixture. For example, the combination of a foundation of oil with strokes of wax crayons overlaid produces a very interesting effect. The oil paint

becomes the background and the wax crayons establish the linear forms and the details. Wax crayons can be dissolved in turpentine and used as a foundation coat into which the solid crayon can be worked as lines. If you use water-based media, you can produce the same effects. A foundation of a watercolor or ink wash can serve perfectly as a base for

overlaying lines. To overlay darker colors than those of the base, use felt-tipped pens or ink to define forms in more detail. To superimpose light colors over a watercolor base, use wax crayons, which will stand out because of their color and their texture. Colored pencils can also stand out brightly against a watercolor base, but the effect is not as dramatic.

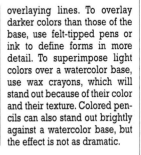

Melted wax. Using wax's property of melting in heat, you can make impastos and textured pictures of great quality.

An example by Joan Sabater of how to create a work using a mixed technique based on watercolor and stroke using pen and ink.

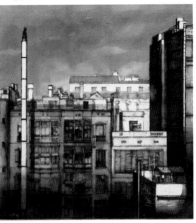

All inquiries should be addressed to:
Barron's Educational Series, Inc.
250 Wireless Boulevard
Hauppauge, New York 11788
http://www.barronseduc.com

International Standard Book No. 0-7641-5228-9

Library of Congress Catalog Card No. 00-102358

Printed in Spain
9 8 7 6 5 4 3 2 1

Note: The titles that appear at the top of the
odd-numbered pages correspond to:

The previous chapter
The current chapter
The following chapter